MARSDEN HARTLEY AND NOVA SCOTIA

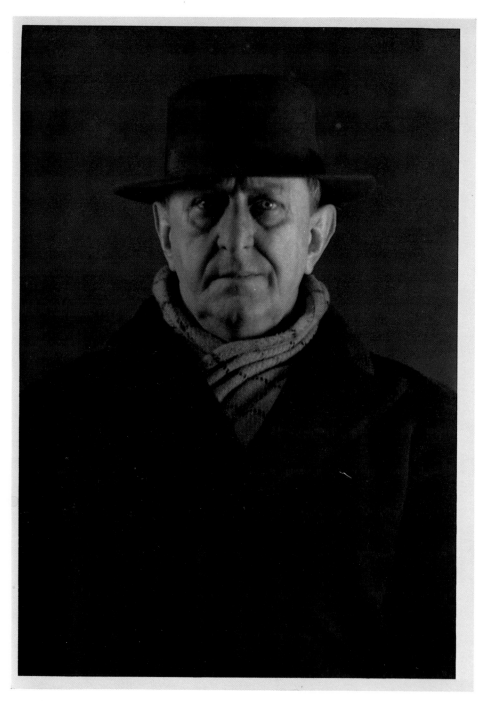

Marsden Hartley, ca 1941. Photograph by Louise Young.

MARSDEN HARTLEY
AND NOVA SCOTIA

Gerald Ferguson, Editor

Essays by Ronald Paulson and Gail R. Scott

Published in association with
The Press of the Nova Scotia College of Art and Design,
and the Art Gallery of Ontario, by

MOUNT SAINT VINCENT UNIVERSITY ART GALLERY
HALIFAX

Published by Mount Saint Vincent University
Art Gallery in association with The Press of
the Nova Scotia College of Art and Design, and
the Art Gallery of Ontario, with assistance
from The Canada Council

Distributed by:

University Press of New England
3 Lebanon Street
Hanover, New Hampshire 03755
(603) 646-3349

in Canada:

The Press of the Nova Scotia College
of Art and Design
5163 Duke Street
Halifax, Nova Scotia B3J 3J6
(902) 422-7381

Design and Production by David LeBlanc.

Printed at The Press of the Nova Scotia College
of Art and Design by Guy Harrison

Canadian Cataloguing in Publication Data

Gerald Ferguson, Editor
Essays by Ronald Paulson and Gail R. Scott

Bibliography: p. 176
ISBN 0-919616-32-1

1. Hartley, Marsden, 1877-1943. 2. Nova
Scotia in art. I. Ferguson, Gerald. II.
Paulson, Ronald III. Scott, Gail R IV.
Mount Saint Vincent University. Art Gallery
V. Art Gallery of Ontario VI. Title.

ND237.H3435A4 1987 759.13 C87-090046-3

Contents

Foreword

Mary Sparling
Director of the Art Gallery
Mount Saint Vincent University

Americans have been discovering the remoter parts of Nova Scotia for over 200 years. When Marsden Hartley arrived in 1935 he found in Nova Scotia the harsh and wild places to which he had always been attracted. The elemental quality of the Northern landscape, and particularly the sea, were familiar, but more intense than his native Maine. His most important discovery, however, was its people on the south shore of our province. Like the Masons with whom he developed a close family relationship, they are mostly descendants of French and German Protestant settlers of the 18th century. Their culture survived, albeit modified, because of the isolation imposed on its communities by geography. As Hartley noted, "I hope one day to be able to do all of this whole coast and drop into such little eyries as this all along—get into the Scotch of it up at Cape Breton and Antigonish and then the Norman French up the Gaspé way. It's lovely to think there's somewhere to go on this side of the ocean and still get the true flavors of the old rich wines of life, and there is a lot of old vintage quality left up this way . . . "

Happily some of those eyries remain, as does some of the heritage of those earlier settlers, including a reliance on the sea. The waters around Eastern Points, Blue Rocks and Lunenburg continue to be harvested and still exact their toll of fishermen, and of those like Alty and Donny Mason who treat the sea with high-spirited and careless familiarity. To sail around the "jigsaw coast" of Eastern Points to-day is to experience those same waters which can be like "a quiet little pool in a green meadow," or quickly turn murderous in the teeth of a gale such as drowned Alty and Donny Mason.

Out of Hartley's grief for the boys, his love for the region and his memories—his "treasured images"—have come the Nova Scotia work which Gerald Ferguson has brought together in this book and the exhibition which prompted it. Displayed at the Mount Saint Vincent University Art Gallery from October 22 - November 23, 1987, it then moves to the Art Gallery of Ontario for January 6 - March 13, 1988 before the individual works return to their separate and widely-separated owners.

We are grateful to Gerald Ferguson of the faculty of the Nova Scotia College of Art and Design for his single-minded determination that the work which flowed from Hartley's Nova Scotian years should be acknowledged as such, and united for exhibition in the province which inspired it. We are indebted too to the generosity of the many individuals and institutions who in loaning Hartley's work made the exhibition and this book possible.

Major funding for exhibition research, production, documentation and circulation was obtained from the Exhibition Assistance Program of the Canada Council. Insurance for the exhibition was provided by the Department of Communications of the Government of Canada through the Insurance Program for Travelling Exhibitions. The continuing support of these federal agencies enables institutions such as ours to organize significant exhibitions regionally which can be shared nationally, and through publications, internationally as well.

In conclusion, I would like to acknowledge the amiable collaboration of the three institutions which participated in the realization of the exhibition and the book: the Nova Scotia College of Art and Design for the use of The Press for the production of all the printed material and for sponsoring as part of its Centennial Year celebrations the symposium; the Art Gallery of Ontario for taking on the role of registrar and for organizing the assembly and dispersal of all the works; and my own institution, Mount Saint Vincent University, for its constant support and enthusiasm for the art gallery and its program.

*My citations are from Hartley's letters to Adelaide Kuntz, published herein.

Foreword

Roald Nasgaard
Chief Curator
Art Gallery of Ontario

Marsden Hartley was a seminal contributor to abstract painting between 1910 and 1920 (in Germany he gained a reputation as an equal of the European pioneers of abstract art), however, he would end his days in Maine two decades later as a landscape and figure painter. In a quite individual way, Hartley succumbed to the European "call to order" after World War I, and, in the United States, to the post-war critical and artistic re-entrenchment from Modernism toward something more indigenously American. Nevertheless the work of those last years, both from Nova Scotia and Maine, motivated as Hartley was by harsh and wild places, vie with his great Synthetic Cubist military icons of 1914-15 as his most brilliant work.

Hartley's long journey from Maine, out into the larger world, geographically and artistically, and back to Maine again (via Nova Scotia, of course, as is the subject of the exhibition) has its own coherence. It also participates in narratives of modern artistic development, other than the strictly Modernist one, where directions are less linear, and where personal desires and spiritual longings as well as historical and geographical contingencies overtake demands for a more purely formal expressiveness.

On occasion Hartley decried the private and the emotional in his art, wanting to rejoin "the ranks of the intellectual experimentalists," rejecting (as in his essay "Art-and the Personal Life," 1928) the tormented imagination of Ryder for the logical principles of Pissarro, Seurat, and Cézanne; or upholding his indebtedness to Segantini the Impressionist as against Segantini the Symbolist. (The series of Mont Sainte-Victoire paintings of 1927 were meant as an intellectual corrective to his previous expressionist excesses.) More commonly, and consistently in the final years, however, he would argue that although "intelligence" may be international in an abstract kind of way, art was entirely a local affair dependent on an artist's personal sensitivity to place. The authenticity of his Nova Scotia and Maine paintings (and thereby also paradoxically their international relevance) was guaranteed precisely by his own "nativeness" to the regions that produced his subject matter. It was by reason of his "heritage, birth and environment" that Hartley eventually (in his essay, "On the Subject of Nativeness—A Tribute to Maine," that introduced his 1937 exhibition of work from Nova Scotia) declared himself "the painter from Maine."

Hartley's commitment to place and his celebration of the spirit dwelling in local character finds its richest expression in his portraits and landscapes from the late 1930s until his death in 1943. But it is incipient from his earliest years in the first independent landscapes done in Maine in 1908 under the influence of Segantini the Impressionist, and in the subsequent "Dark Landscapes" painted in the shadow of Ryder; in the reprise of the "Dark Landscapes" done from memory in France in 1924; and in the "druidic" works from Dogtown in the early 1930s, and the ensuing monumental mountainscapes from Garmisch-Partenkirchen. All these works share a relationship to stately, stark and lonely places, or as in Nova Scotia, to people who are hardy, frank and earnest. Silence is the communicative medium through which the artist and his subject meet. In Nova Scotia and Maine these qualities become specifically identified with the "north country" where perilous nature issues a stark poetry of environment and behaviour able to reveal virtues and mysteries ancient and unspoiled.

The development of Hartley's career cannot be reduced to a simple formula. But the terms of his late idealization of northern wilderness—his quest for almost mystical meaning in remote landscapes and people, his regionalism and notion of nativeness, along with the kinds of formal solutions he resorts to to wrest inner meaning from his motifs: his heroic scale, his vigorous expressionist execution, his bold frontal spatial conflations, all achieved through

his abiding faithfulness to observed nature—constitute an overwhelming resurgence of a tradition whose roots lie at the close of the preceding century. The compositional types of the crashing waves, the Mount Katahdins, and the stern Archaic Portraits, and Hartley's compulsion to reveal the unseen in what can be seen, unite him with a number of earlier artists from the turn of the century in Europe and from slightly later in North America, who in similar ways in both landscape and figure painting sought new ways to invest their vision of the external world with subjective and spiritual meaning. These are almost exclusively northern artists who on the one hand are descendents from an older Romantic tradition, but on the other, belong more specifically to a Northern aspect of the Symbolist movement as represented by the work of Edvard Munch and a large group of fellow Scandinavians, Ferdinand Hodler, the early Piet Mondrian, the Group of Seven and Emily Carr in Canada, and such American painters as Arthur Dove and Georgia O'Keeffe.*

Like his Symbolist predecessors, whose means in the early twentieth century also easily transposed themselves into a more personal and painterly expressionism, Hartley transformed depicted nature from a mirror of the physical world to one of feeling and mind. His rapture with the daily routine of the lives of the fishermen and their women on the coast of Nova Scotia, as described in *Cleophas and His Own,* might have implied that the paintings inspired there should have been genre pictures, like those by Segantini the Symbolist that he had admired in his youth. But like the Northern Symbolists he rarely brought man and nature together, as if it would diminish both to have to accommodate them in a shared space which must inevitably open physically onto descriptive banality. Instead the landscapes rise vertically and loom, monumental and threateningly close, and the figures (like those of Hodler) fill the whole of their space surrounded at best by mere emblems of context.

Hartley thus spent his last years posing metaphysical questions and searching out mythic archetypes and depths of inner experience as a late expressionist variant of realist and regionalist Symbolism, instead of experimenting with more extreme forms of abstraction as were simultaneously being pursued by the Abstract Expressionists. But this in no way diminishes his stature as an artist or lessens the emotional power of his work. The appearance of so many painting neo-styles in the present decade has undermined the faith in a linear genealogy of art which seemed to serve us so well in the recent past, and which by its very terms had to consign the late work of Hartley, however much respected, to historical byways. It is instead clearer that ways of doing may pursue more circuitous paths; that any one way does not necessarily play itself out in the first instance, but that new times, different places, and accumulated experience may propose yet other moves to be made that yield fresh and unprecedented insights into human experience. How else are we to read Hartley's particular play of tradition and innovation?

There are interpretations of these late Hartleys that read in their flattenings and simplifications the processes of reduction that would resolve into the non-referential planes of colour or the gigantic gestures of the Abstract Expressionist generation. Indeed, all the earlier Northern Symbolists understood something essential of the expressive capacity of line, shape, and colour, and their work often hovers on the very edge of a purer abstraction. None of them, with the exception of Mondrian, crossed it and the pattern of their work, if one can presume, suggests that they would not have, given the opportunity. Rather, Hartley's career ran somewhat in reverse, as did those of his American contemporaries, Dove and O'Keeffe, (with whom he shared so many things, not least, participation in the confluence of ideas of European Symbolism and American Transcendentalism in the circle of Alfred Stieglitz), who had been innovatively conversant with the first stages of the development of abstraction but had held back, continuing to need to draw sustenance from communion with a native landscape.

*The case for the special character of Northern Symbolism is more fully developed in my *The Mystic North: Symbolist Landscape Painting in Northern Europe and North America 1890-1940* (Toronto, University of Toronto Press, 1984).

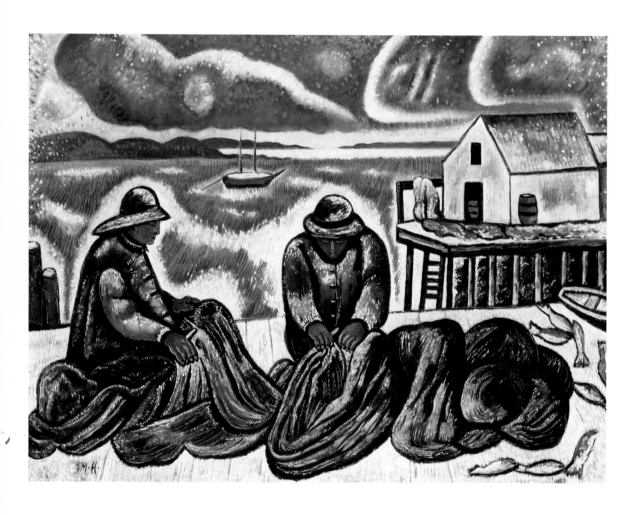

Plate 1
Nova Scotia Fishermen, 1938.
Oil on board, 22 × 28″
IBM Corporation, New York.

Introduction

Gerald Ferguson

The Marsden Hartley retrospective at the Whitney Museum in 1980 was a revelation to most of the museum-going public.[1] Until then Hartley was best known for his German martial paintings and New England landscapes, but the Whitney exhibition presented a far more varied and complex artist. The retrospective began with his professional debut in 1909 at Alfred Stieglitz's Little Galleries of the Photo-Secession, better known as "291", which was the first one-man show of an American artist in that gallery. It went on to trace Hartley's career through two world wars, most of which he spent in Europe as a member of the expatriate community. The Whitney retrospective was a valuable overview with an extensive biographical catalogue, but it only included paintings. Since there are not more than four hundred paintings by Hartley known, one has to look also at the drawings and especially the literary estate to recognize the significant change that occurred in his work and thought as a result of his Nova Scotia experience.

Hartley's last stay outside the United States was in Nova Scotia during 1935 and 1936. The chronology of that sojourn is detailed in his letters to Adelaide Kuntz, published herein. The letters introduce us to the Mason family who befriended and boarded the fifty-eight year old Hartley in their island home at Eastern Points, near the mainland fishing community of Blue Rocks. Among other things, the letters provide a detailed portrait of each family member: Francis Mason, the family head and island patriarch; Francis' wife, Martha; their two powerful sons, Alty and Donny; and the daughters, Alice and Ruby. The letters also furnish a revealing description of the time, forming a factual buttress to *Cleophas and His Own*, the story that Hartley would write about the Mason family, their island life, and the sudden deaths of Alty and Donny. *Cleophas and His Own* is a commemoration, as later the painted portraits would be, of what Hartley described as " . . . one of the most

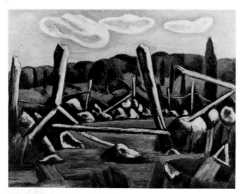

The Old Bars, Dogtown, 1936. (see Plate 10)

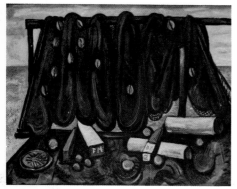

Lobster Buoys and Nets, 1936. (see Plate 11)

elevating experiences of my life—in truth, the most elevating" (p. 91). ✗

After Hartley's first stay at Eastern Points, he returned to New York City and a show at Stieglitz's new gallery—An American Place, a name in keeping with the chauvinism arising from the Great Depression. His Bavarian mountain scapes and "Bermuda Fantasies", executed in 1934 and 1935, were met with critical hostility, prompting him to write Adelaide Kuntz, "I propose a 100% Yankee show next year to cram the idea down their throats till it chokes them even."[2]

Hartley found respite and reinvigoration on his return to Eastern Points in July, 1936. That summer was tranquil and productive for him. He painted his last Dogtown series (pl. 10), which was actually the boulder strewn landscape of Blue Rocks[3], as well as fishing gear and sea debris still lifes (pls. 11 & 12). The security and "connectedness" that Hartley felt as part of a family unit was not to last. On the night of September 19, the two Mason sons—Alty and Donny—and their cousin Allen, were drowned in a storm on their return from an evening of revelry on the mainland. "It is done, that's what it is—it's all done, and so it was all done—the wonderful Adelard, Etienne, and their pretty little cousin GONE" (p. 103). The drownings were a wrenching ordeal for Hartley which provided an epic conclusion for *Cleophas and His Own* and precipitated an immediate change in his paintings. The still lifes and landscapes painted earlier that summer are in marked contrast to the dark foreboding *Church on the Moors* (pl. 14) and *Stormy Sea #2* (pl. 16) done after the tragedy.

After spending three months consoling the family, Hartley left Eastern Points in December, 1936 knowing he would never return with the boys gone. He went directly to New York City where he prepared for his last show at An American Place in April, 1937. In his foreword to the catalogue, Hartley tried to fulfill his promise of "a 100% Yankee show" by writing "On the Subject of Nativeness—A Tribute to Maine." In that short essay Hartley devoted nearly one third of the space to Nova Scotia, explaining its linkage to Maine. To justify his years in Europe, he went on to say, " . . . these hills [of Maine] wherever I went; looking never more wonderful than they did to me in Paris, Berlin, or Provence." He then declared himself "the painter from Maine" and concluded:

> And so I say to my native continent of Maine, be patient and forgiving, I will soon put my cheek to your cheek, expecting the welcome of the prodigal . . .[4]

Hartley's rationalization and proclamation failed to convince the aging and insular Stieglitz, who seemed comfortable with John Sloane's definition of American Art: "An American picture is a picture done by an American in America." Landscapes of Nova Scotia could hardly have been a success in such a context. Almost penniless and in ill health, Hartley left for Maine in June, 1937 determined to lay his rightful claim as an important American painter, knowing he needed that venue to make his claim credible. Fortunately for Hartley, his subsequent dealers, Hudson Walker, and Paul Rosenberg believed and promoted this new image.

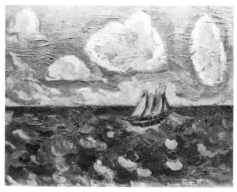

Stormy Sea #2, 1936. (see Plate 16)

Hartley's first paintings on his return to Maine were a group of landscapes which, not surprisingly, show nature as a malevolent force. When he took up residence on the island of Vinalhaven in 1938, he began the portraits he had contemplated in his letters to Adelaide Kuntz two years before. These so-called Archaic Portraits were the first figure paintings in Hartley's long career. *Fishermen's Last Supper* (p. 14) shows the Mason family gathered for dinner and accurately records the scale, colour and furnishings of the room—even the picture above the table—all of which is extant today. The eight-pointed stars (a motif he used as early as 1912) above the heads of Alty and Donny signify their departure, as do the wreaths on the chairs opposite them. The vacant chair in the centre is for the absent Hartley. The words MENE MENE derive from the "writing on the wall" passage in the fifth chapter of the Book of Daniel and they, together with TEKEL UPHARSIN, signify that God "numbers, weighs and divides" according to His sovereign will. Other portrayals of the family were titled with French Canadian names to protect their privacy: Francis, whose fishing boat was the Gilda Gray, *Cleophas, Master of the Gilda Gray* (pl. 6); Alty, whose speed boat was the Phantom, *Adelard the Drowned, Master of the Phantom* (pl. 2); "Aunt" Martha, *Marie Ste. Esprit* (pl. 3) and *Nova Scotia Woman Churning* (pl. 18); Alice with the spectral figures of her brothers Alty and Donny, *The Lost Felice* (pl. 4); and Francis and Donny mending their fishing nets, *Nova Scotia Fishermen* (pl. 1).

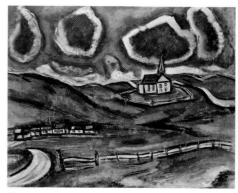

Church on the Moors, Nova Scotia, 1936. . (see Plate 14)

In this new figurative work Hartley was weighing the two great influences of his life—Paul Cézanne and × Albert Pinkham Ryder. On a formal level, the archaism and monumentality of the figure, even the paint handling, is reminiscent of Cézanne. The psychology of the work, however, invokes the lonely vigil of Ryder, confirmed in the only memory portrait other than those of the Masons, *Portrait of Albert Pinkham Ryder* (p. 22).

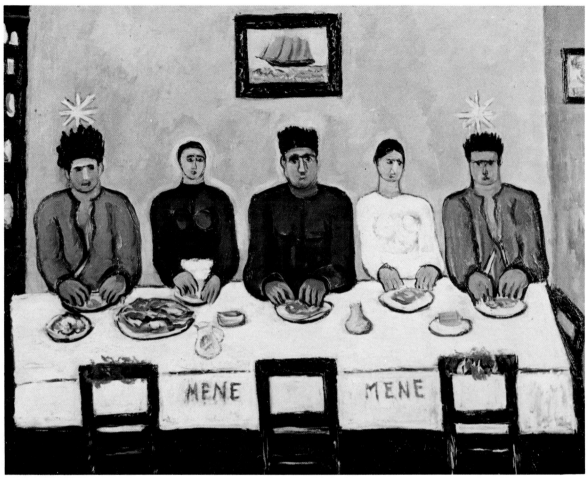

Fishermen's Last Supper, 1938.
Oil on board, 22 × 28"
Private Collection, courtesy
Graham Modern Gallery, New York

While these were Hartley's first figure paintings, they were not his first portraits. In 1914-15 he did a series of Synthetic Cubist pictures which utilized the iconography of military emblems and insignia. Known as the German Officer Portraits, they were done in response to an earlier death, that of a young lieutenant friend, Karl von Freyburg (p. 21). Hartley was then associated with the Blaue Reiter in Germany after having enjoyed the enthusiastic support of Gertrude Stein in Paris.

Alone and rejected in Maine in 1938, Hartley followed the same Symbolist programme of investing subjective feelings with visible form, only now the space is dominated by the frontal and brooding immediacy of the figure, not their symbolic tokens. Once Hartley gave himself permission to use the figure, possibilities opened to him which resulted in the most intensely personal and memorable images he ever made. The "prodigal" may have returned, but the subject matter he dealt with transcended Maine and America; it was rooted in the

human bonding and loss he experienced in Nova Scotia.

Unable to continue his peripatetic lifestyle, Hartley found Corea, Maine in 1939 through his painter friend, Waldo Peirce. Corea was, and still is, an isolated fishing community which reminded him of Eastern Points. Not long after arriving in Corea, financial relief came from Hudson Walker who purchased twenty-three paintings for five thousand dollars. This was the first economic security that Hartley had ever known, which not only gave him the opportunity to paint, but the freedom to pursue work that had even more limited market appeal. The period from 1940 until his death in 1943 was the most productive in all respects for Hartley. Among the works produced were a range of figure paintings, the most startling of which utilized overt Christian iconography. In her essay, "The Making of a Narrative," Gail Scott traces Hartley's spiritual concerns from his early interest in entering the ministry through his readings of various Christian mystics. Christian Symbolism exists in the "Intuitive Abstractions" of 1912, and his Mexican paintings of 1932, but it was not until Hartley met Francis Mason (Cleophas) that he was convinced that the Christian ideal could exist in the modern world. Of the Masons he observed that there was a "touch of Christian martyrdom" about their life ˅ and went on to say, " . . . I have never been so near the real thing before" (pp. 41, 43). In the manuscript Hartley is able to confide to the sympathetic Cleophas a mystical experience he had two years before in the Bavarian Alps. He goes on to describe Cleophas in the island schoolhouse during Sunday service:

> . . . I could see the holiness and wanted to
> see it, it came from his face over me and I
> liked it that way, as I must have all things
> of that nature humanized for me, it is so
> natural—then. (p. 95)

Finally, there was the example of Francis Mason whose faith was unwavering in the aftermath of a devastating tragedy. For Hartley this was a monumental demonstration of the spirit too powerful to contain in some oblique or arcane representation. In a pietà (pl. 23) an anemic and vulnerable Christ is cradled by powerful men—fishermen all—a parallel and metaphor of His original disciples. Hartley was made aware and communicates to us that it is men like Francis Mason who support and sustain the viability of Christ. In the "religious" paintings and other works, the Masons are remembered to the last. A photograph of the studio after his death shows *Roses* (pl. 27), a symbol associated with

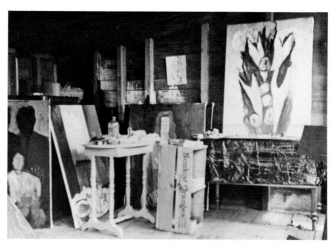

Marsden Hartley's studio, Corea, Maine, September, 1943.

both Francis and Alty, transformed into a transcendent bouquet as opposed to the earlier funerary wreath cast on the waters (pl. 21). And in the lower left of that photograph is an unfinished portrait of the Mason family (pl. 26).

Hartley's fortunes may have been enhanced by Hudson Walker, but the reception of his work was still limited to a small audience. In 1941, America was at war once again with his beloved Germany. The atmosphere during the 1944 memorial retrospective of Hartley's work at the Museum of Modern Art was no less charged than it had been in 1916 when he was forced to disavow the German content of his Berlin pictures. In a review of the retrospective for *The Nation* Clement Greenberg said, " . . . during the last war he flirted with cubism and a kind of abstractionism, giving the latter a German accent and typically and almost completely misunderstood both."[5] Greenberg ignored the figurative work altogether.

In the post-war era New York became the heir of Paris as the world's art centre, with its home grown and internationally acclaimed Abstract Expressionism. No serious person could entertain the likes of Marsden Hartley's figurative paintings. His European works were equally difficult to digest for an America whose new role was to champion an art independent of Europe. It was not until Modernism had run its course—which coincided with the 1980 Whitney retrospective—that a larger community could view afresh Hartley's complex and necessarily varied concerns, and begin to re-evaluate his body of work, as Ronald Paulson has so compellingly done in his essay, "Marsden Hartley's Search for the Father(land)."

Hartley's contribution to the early phase of Modernism culminated in the German Officer paintings of 1914-15. Their rejection during World War I and the subsequent social conditions between the wars marked Hartley's stylistic and intellectual path with frustration and loss of spirit as was the case for others of his generation. During this period the course Hartley and many of his contemporaries chose was refuge in the artistic and intellectual circles of Europe. When the Great Depression forced Hartley to leave Europe, a chance encounter in Nova Scotia proved seminal in the development of the most profound work of his career. Few artists are able to achieve, let alone exceed, the force and invention of their early work. We are enlarged by his example and discovery.

Notes

1. Haskell, Barbara. *Marsden Hartley,* Whitney Museum of American Art, New York, March 4 - May 25, 1980.

2. Letter to Adelaide Kuntz, May 1936, Yale University Archive.

3. Dogtown Common is an area outside the town of Gloucester, Massachusetts. Hartley did two series of paintings while there in 1931 and 1934. The third Dogtown series are memory paintings inspired by the similar landscape of Blue Rocks, and executed in Nova Scotia during the summer of 1936.

4. Scott, Gail R. (ed.) *On Art* by Marsden Hartley. Horizon Press, New York, 1980. pp. 112-115.

5. Greenberg, Clement. "Art", *The Nation,* 159 (December 30, 1944) pp. 810-811.

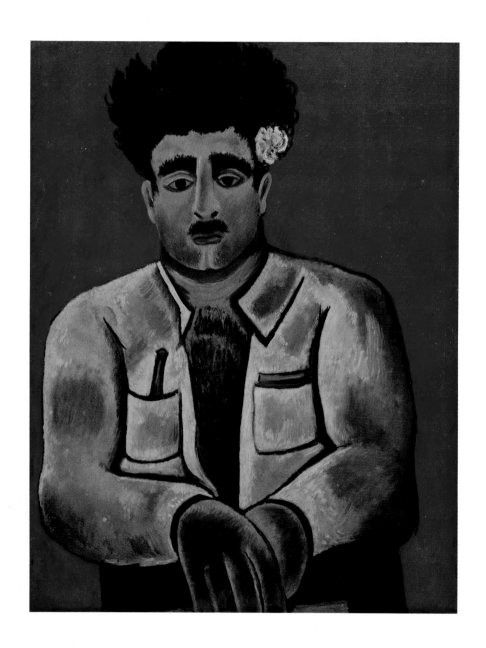

Plate 2
Adelard the Drowned, Master of the Phantom, 1938-39.
Oil on board, 28 × 22"
University Art Museum,
University of Minnesota, Minneapolis;
Bequest of Hudson Walker from the Ione
and Hudson Walker Collection.

Marsden Hartley's Search for the Father(land)

Ronald Paulson

Hartley's career can be read as an allegory of the American painter in search of his subject, and, as so often happens, this was also an attempt to replace, ultimately confront and master, an absent, lost, or withdrawn object.[1]

Hartley's career began and ended in Maine, but in between he spent most of his adult life in Europe taking in the phases of modern art at their sources. He started as a landscape painter of the Maine mountains, those flat ranges that are seen by the ordinary spectator as a panorama, hardly threatening let alone sublime. But painted by Hartley in vertical slices with a few farm buildings huddled at the bottom, the effect was of an oppressive yet protective shape bearing down on tiny traces of life. Then, having decided to be an artist, he went to France to absorb Analytic and Synthetic Cubism and to Germany to study the paintings of Kandinsky, Marc, and others and develop his own brand of what he called "intuitive Abstraction"—all apparently, as it turned out, in order to return finally to become the "Maine Artist" and paint the masterpieces of his final decade.

This peregrination, which showed how badly Hartley wanted to be (and for a time was) part of the international art scene, reached its furthest point of alienation from the American subject, and the American public, with the homages he paid to Cézanne in his synchromatic paintings of Mont Sainte-Victoire—a very different shape from the blunt Maine mountain ranges. These paintings strained beyond recovery his relations with his most faithful supporter and dealer, Alfred Stieglitz, who believed in an American art independent of European influence. Ten years later Hartley ended his career with his absolutely personal (or American or Maine Artist) paintings of Mt. Katahdin, which were also his own version of Mont Sainte-Victoire, and the end of his struggle to relate the art of Europe and America.

Mont Sainte-Victoire, 1927.
Oil on canvas, 32 × 39½"
Mr. and Mrs. Harry W. Anderson
Atherton, California.

No. 50 [Mount Katahdin], 1939.
Ink and pencil on paper, 8½ × 11¼"
The Marsden Memorial Collection
Bates College, Lewiston, Maine.

Dogtown with Gloucester in the Background, 1931.
Lithographic crayon on paper, 12 × 16"
Private Collection, courtesy of
Rosenfeld Gallery, New York.

He had very early on become aware of the paintings of Albert Pinkham Ryder, and then in the last decade of his life returned to the Ryder style—the only style, he said, on which an American tradition could be founded— and painted the remarkable portrait of Ryder in his stocking cap, with his long Ancient-of-Days beard tucked into his jacket. By paternalizing and internalizing him, Hartley returned to Ryder in the same way that he returned at last to Maine and Mt. Katahdin.

As he moved from place to place he defined his art in terms of the polarities of inner feelings (or spiritual values) and formal values, with both of these terms set up against observed nature. He learned from the Cubists, but he gravitated to the German Expressionists, whom he said he preferred to the intellectual French formalists because they "are more sturdy like ourselves." He referred to their mystical leanings, their "spiritual values" and "expression of inner feelings," which he felt were closer to his own aims, nurtured not only on Ryder but on the writings of Emerson, Thoreau, and the Transcendentalists. In practice this meant a certain sort of symbolism, but also an emphasis on the paint surface that linked him to Kirchner and Beckmann, that remade Ryder in the angry idiom of Berlin in the 1920's.

The sidelong way Hartley came at being the Maine Artist included his being forced to return to America for financial reasons—literally in order to survive by becoming (probably following Stieglitz's advice) a regional painter; his being psychically unable actually to return to Maine, living across the state line in New Hampshire; and then going to Dogtown, Massachusetts, to find yet another, a truer version of his Maine. The Dogtown pictures can also, of course, be seen as yet another homage to Cézanne, this time to the paintings of the rocks in the Fontainebleau Forest. Like the earlier versions of Maine in Germany and New Mexico, Dogtown was followed by others in Mexico, the Bavarian Alps and a Nova Scotia island, before Hartley finally settled into Maine with all of this complicated baggage.

Hartley found it difficult to return to—or face— Maine because of the childhood memories of abandonment he associated with the countryside. The biographical facts are that his mother died when he was eight, his father remarried and then left his youngest son (christened Edmund) behind in Maine. "From the moment of my mother's death," Hartley wrote, "I became in psychology an orphan, in consciousness a lone left thing to make its way out for all time after that by itself." This was a time so hard, so traumatic that it was

only with great effort, and much doubling back, that forty years later he could make himself resettle in Maine—even then spending as much time as possible in New York City. In between he never stayed in the same house longer than ten months.

Hartley's career is the allegory of the American artist whose relationship to his homeland vacillates between love and hate; but there is also the suggestive fact that he replaced the name Edmund given him by his real father and mother with Marsden, his step-mother's maiden name. Barbara Haskell in the Whitney catalogue surmises that he "perhaps wanted to reconcile himself with his father and to draw closer to his step-mother,"[2] but the insecure identification with his step-mother is presumably related to his vigorous, and ultimately unsuccessful, identification with Europe and European art, leading to his eventual acknowledgement of his given name and his father—precisely in the paintings of Mt. Katahdin/Sainte-Victoire.

It was not only the symbolic version of Maine that he found outside Maine itself in Nova Scotia, but also the family he had lost forty years before, recovered in the Mason family with whom he lived for a short idyllic time. But once again it was a family found and almost at once, lost. He had made up for the loss of his father in the early European years by his attachment to young German officers (one reason Germany attracted him was the large homosexual community in Berlin), in particular Karl von Freyburg, whose image and whose death in the early months of World War I contributed to the major abstractions, the War Motifs, as Hartley called them. This love, though in the context of a family now rather than an officer corps (symbolized in the War Motifs by the regimental insignia, medals, tents, etc.), ended as abruptly: Alty Mason and his brother and cousin drowned in a storm between the island and the mainland.

The motive was personal, and it could be argued that his greatest art came (in these two phases of 1914-15 and the 1930s) from a lost love. This time Hartley used the Ryder mode instead of Synthetic Cubism, finding objective correlatives in paintings like *The Toilers of the Sea*. But he was also painting out of a social milieu seen in a particular political context, beginning with Germany before and after the First World War, but also including America in the Depression. The stages can be enumerated as (1) Stieglitz's belief that now "You have really no 'practical' contact in Europe and you are really without contact in your own country"; (2) Hartley's disillusionment with Europe—"how barren Europe is—

Painting No. 47, Berlin, 1914-15.
Oil on canvas, 39½ × 31⅝"
Hirshhorn Museum and Sculpture Garden,
Smithsonian Institution,
Washington, D. C.

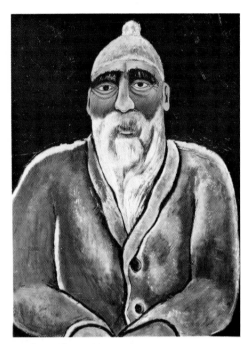

Portrait of Albert Pinkham Ryder, 1938-39.
Oil on board, 28½ × 22¼"
Mr. and Mrs. Milton Lowenthal,
New York.

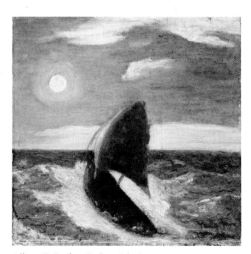

Albert P. Ryder, *Toilers of the Sea,* 1915.
Oil on wood, 11½ × 12"
The Metropolitan Museum of Art,
New York.
George A. Hearn Fund, 1957.

of ideas—of belief in art—or even of spiritual prospect. It is a country of forgotten ideas aesthetically speaking"; (3) his further disillusionment with America itself, which on his return revealed itself as a place of spiritual and physical oppression: "how chauvinistic and xenophobic America had become." It is not surprising that he found in the survival of the ice-age moraine and primeval rocks of Dogtown Common a correlative to the situation he (and many other American artists) felt in the Depression years. The desolation, after all, included the foreclosure and dispersal of the last inhabitants of Dogtown and the holes where cellars had once been, the landscape that mingled rocks and ruins, and Babson's jingoist inscriptions on the rocks ("Get a Job," "Never try, never win"). Hartley's Dogtown was a graphic adumbration of Charles Olson's twenty years later in his *Maximus* poems—the end of all things, of America, and the Post Office, equally of the ancient city of Tyre and of Massachusetts Highway 128.

Then with the trip to Nova Scotia Hartley translated Dogtown into the iconography of the rocky coast and stormy sea, the cause of Alty's death (and the family's breakup). At the same time, in the convention of votive figures he had explored in New Mexico, he found a model for the Archaic Portraits of the Mason family, the *Last Supper* and *Pietà,* and finally the isolated figure of a dead gull, plover, black duck or white cod.

The Masons, even before the tragedy, were seen by Hartley as one aspect of the primitive or elemental nature he felt in the Nova Scotia landscape: "There is a touch of Christian martyrdom about the life anyhow, for they endure such hardships and hate any show of cheap affection." The extent of the transformation can be seen by juxtaposing photographs of the nattily-dressed male Masons with the right-angled icons he constructed of them. The representation was based on German Expressionism and the political simplification of Orozco murals he had seen in Mexico in 1932. He was trying to express ideas of working class art, and this meant that he conflated proletarian imagery (as in the murals of the WPA artists) with early Renaissance iconography of Crucifixions, Pietàs, and Last Suppers. The resulting figuration, however, joined the Christological figures with iron-pumping beach boys, their huge chests and biceps covered by checked lumberjack shirts. The spectator is assigned a precarious position in relation to these strange allegories, somewhere between the patriot standing before the Renaissance Christian imagery of the Mexican muralists and a deeply anguished private lover asked to participate in the hermetic iconography of

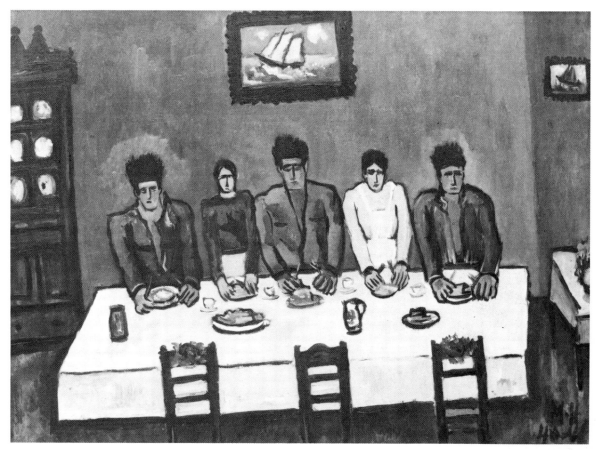

Fishermen's Last Supper—Nova Scotia, 1940-41.
Oil on board, 30 × 41"
Roy R. Neuberger,
New York.

a gay subculture. The *Fishermen's Last Supper* pictures are painted on a tilt that suggests the viewer's—or sitter's—rocking on a ship at sea, repeated in the tilt of the foundering ship on the wall, and made more eerie by the upright electric shocks of hair on the heads of the drowned male members of the family. We have no choice but to view the picture through the grieving eyes of the artist, who is elevating his personal obsession by means of techniques that carry with them public and political associations of political oppression and upheaval.

"One must destroy life," Hartley wrote, "and destroy it with images greater than itself." Looking back over his career, we see on Hartley's part an initial reliance on verbal allegories—reaching from the numerological symbolism in the War Motifs (for example, eight) to the elaborately literary quality of *Eight Bells' Folly, Memorial for Hart Crane* and up to the first version of *Fishermen's Last Supper*, with eight-pointed stars over the heads of the drowned brothers and "MENE MENE . . . " inscribed on the tablecloth. The second stage was to remove words, leaving only the symbol, stark and alone. The War Motifs had retained the concreteness of ideas Hartley

associated with the German painters. As Fairfield Porter puts it, "So in abstract German painting the details embody general ideas, and the painting as a whole is something that can be taught rather than experienced."[3] This perhaps explains why I find Hartley's landscapes and portraits surrounding the Masons so much more moving than the symbols with which he mourned Karl von Freyburg. His shapes have primitive, animalistic, and even surrealist sources now rather than the cubist sources of the abstractions.

The landscape animates nature, not in the Transcendentalist sense but in that of Melville's *Moby Dick* and its great white whale. In *Northern Seascape, Off the Banks* , the shore rocks have become sharks' teeth (recalling the shark mouth in the foreground of *Memorial for Hart Crane*) and in *Hurricane Island, Vinalhaven, Maine,* the row of rocks in the immediate foreground and the rocks opposite, separated by a savage line of surf, resemble an

Eight Bells' Folly, Memorial for Hart Crane, 1933.
Oil on canvas, 30⅝ × 39⅜"
University Art Museum,
University of Minnesota, Minneapolis;
Gift of Ione and Hudson Walker.

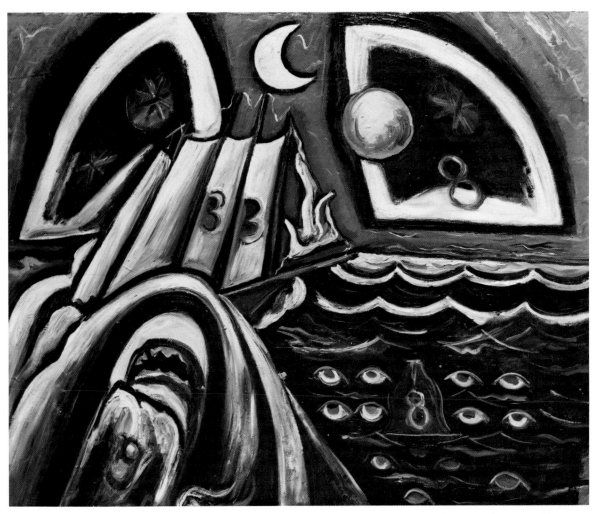

Marsden Hartley's Search for the Father(land)

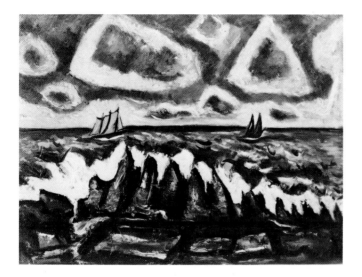

Northern Seascape, Off the Banks, 1936-37.
Oil on board, 18³/₁₆ × 24″
Milwaukee Art Museum Collection;
Bequest of Max E. Friedmann.

Hurricane Island, Vinalhaven, Maine, 1942.
Oil on canvas, 30 × 40″
Philadelphia Museum of Art;
Gift of Mrs. Herbert Cameron Morris.

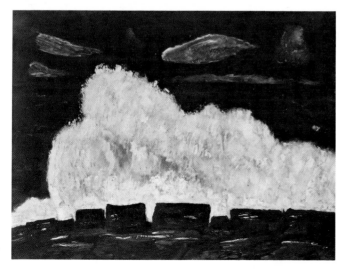

Evening Storm, Schoodic, Maine, No. 2, 1942.
Oil on board, 30 × 40″
Mr. and Mrs. Milton Lowenthal,
New York.

open whale's mouth. In both paintings the heavy clouds in the sky threaten a crushing force from above, as the rocks do from below; the tiny ships on the horizon appear to be ground between these opposing stones. (In *Northern Seascape*, it is the same ship in the picture on the wall of *Fishermen's Last Supper—Nova Scotia*.)

In these landscapes and in *Evening Storm, Schoodic, Maine, No. 2* there is a horizontal line that is being pressed from above and below, which in *Evening Storm* is broken, thrust through by a giant wave. The wave has taken on the shape of Mt. Katahdin, a roughly phallic shape of the sort Paul Rosenberg pointed out in Hartley's paintings as early as 1922 (in *Port of New York*). Once he had turned away from the high horizontal line of mountain range in the early Maine landscapes, Hartley developed a shape resembling a Gothic arch which dominated his abstractions. This is the shape of the War Motifs, the pile or collection of medals, regimental banners, topped with a plumed German officer's hat and triangular soldiers' tents (in the Indian paintings, teepees). These conical shapes, which eventuate in the Garmisch-Partenkirchen and Mt. Katahdin paintings, can be taken in the War Motifs as a kind of portrait of von Freyburg, in the manner of Marius de Zayas or (in words) of Gertrude Stein, and so an ambivalent representation of the things about von Freyburg Hartley both admired and now saw to be only a heap of vanities—truly ambiguous, as they must have appeared to Americans who looked dubiously at the pictures when they were exhibited just before America's entrance into the war. But the shape is essentially the totemic one of the father and his surrogate the mountain, reappearing finally in both the archaic votive portraits (themselves derived from the similar shapes of the Madonnas Hartley painted in New Mexico) of the Masons, Ryder, and other symbolic "American" figures (including Lincoln, and even the funerary image of John Donne wrapped in his shroud).

Mont Sainte-Victoire then becomes Mt. Katahdin, the breaking wave on the Maine shore assumes the shape of Katahdin, and both of these shapes—so different from the flat range of mountains in the early landscapes—recapitulate the Gothic arches of the abstractions. And yet Hartley himself, before he could paint those final images, felt he had to confirm these images-out-of-art by going to Mt. Katahdin.

He had read Thoreau, and he must have known *The Maine Woods* in which Thoreau describes his agonizing climb of Katahdin.[4] Halfway up Thoreau stops, looking around at the boulders and broken trees, and concludes

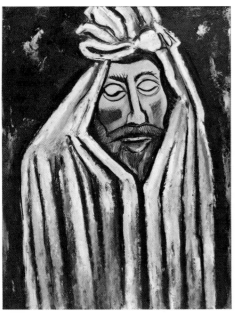

The Last Look of John Donne, 1940.
Oil on board, 30⅜ × 23¼"
The Brooklyn Museum;
Gift of Mr. and Mrs. Milton Lowenthal.

that whereas in Europe nature is seen as having human meaning, in the New World it bears no kinship whatever with mankind. He sees his struggle up the mountain as "scarcely less arduous than Satan's anciently through Chaos" (p. 140), and he repeatedly quotes Milton's description of Satan struggling through the murky area between heaven and hell. For this association of the mountain with nature-as-chaos and himself with Satan includes the notion that mountains are the high places where gods live, and he writes,

> It is a slight insult to the gods to climb and
> pry into their secrets, and try their effect
> on our humanity. Only daring and insolent
> men [like Thoreau and Satan], perchance,
> go there. Simple races, as savages, do not
> climb mountains—their tops are sacred and
> mysterious tracts never visited by them.
> (p. 144)

As Hartley also knew, the Indians had made a god of the mountain. The climber mythologized his climb in terms of these contradictions, and the painter carried them with him when he painted the distant peak— which, moreover, from a distance regained its resemblance to the symbol of art for a painter of Hartley's generation, Cézanne's Mont Sainte-Victoire. Hartley, like Thoreau, placed himself in the position of the Satanic challenger scaling and controlling the Father through representation.

From the top, as Thoreau wrote, "we could overlook the country west and south for a hundred miles"—seeing the whole state of Maine—though it was nothing but "immeasurable forest" with "no clearing, no house". This is not the view Hartley paints; he returns to earth and paints the mountain as it stands, distant and unapproachable. And yet it is significant that he had to "climb" it first (in the sense that he approached and camped at its foot), before returning to the safe spot from which the sublime can be represented without overwhelming the spectator with the threat of engulfment.

On the mountain—climbing the mountain—the experience was more like Dogtown. It was alien to man:

> Man was not to be associated with it. It was
> Matter, vast, terrific,—not his Mother
> Earth that we have heard of, not for him to
> tread on, or be buried in,—no, it were being
> too familiar even to let his bones lie there—
> the home this of Necessity and Fate. There

Mark Rothko, *Number 19,* 1958.
Oil on canvas, 7′11¼″ × 7′6¼″
The Museum of Modern Art,
New York.
Given anonymously.

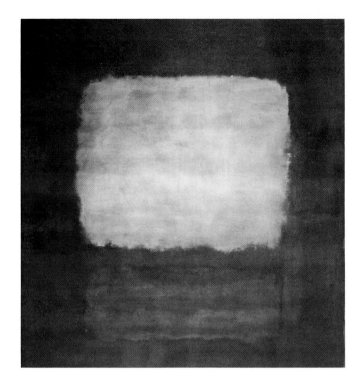

was there felt the presence of a force not
bound to be kind to man. It was a place for
heathenism and superstitious rites,—to be
inhabited by men nearer of kin to the rocks
and to wild animals than we. (p. 148)

In Dogtown Hartley had been content to represent
this experience of being-in, or of Satan slogging through
chaos. But for Mt. Katahdin he had to return to earth
and look back, turning it into a totem, and incorporating
the experience into the larger experience of the totem he
associated with his earliest memories of Maine and its
aesthetic equivalent in the landscapes of Cézanne.

Hartley's influence on the generation of artists that
followed him is only beginning to become apparent.
Milton Avery's landscapes and seascapes certainly show
the effect of contact with Hartley's late paintings,
including the figure paintings of the Mason family. It is
difficult to imagine Philip Guston's last phase paintings
without Hartley's Dogtown paintings. But in a less direct
way the crucial case is Mark Rothko. Hartley's progress
and his final hard-won image hauntingly evoke the
image Rothko arrived at in his mature paintings. This
image began as a modular background against which
Rothko placed totemic or archetypal figures, which he
then removed to leave the stark rectangles with which
we are familiar. The Rothko rectangles can be

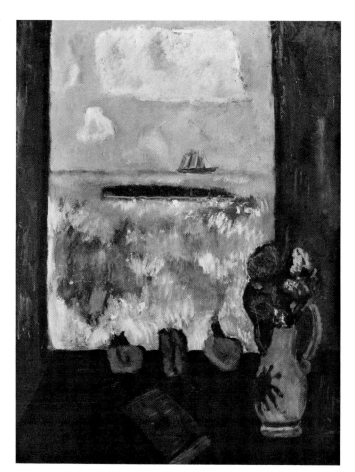

Summer Sea, Window, Red Curtain, 1942.
Oil on canvas, 40 × 30"
Addison Gallery of American Art,
Phillips Academy,
Andover, Massachusetts.

approached as a substitute for the monoliths which
originally appeared in front of them, along the line of
Hartley's votive Madonnas and War Motifs. Or they can
be read as a Marsden Hartley landscape in which the
immense pressure of the rocks below and the rocklike
clouds above come to bear on the horizon line in which
Hartley sometimes places doomed sailing ships. The
pressure exerted on that horizon is much the same
exerted by Rothko on his: a terrific tension between
powers held in check and ready to explode, an expression
of energy compressed, focused on a line, as in Rothko's
last paintings where there is no more than the glowing
line separating a light and a dark area of paint. (Lawrence
Alloway described a Rothko as presenting clouds with
the weight of oceans or suns," which "vibrate, advance,
and expand." Indeed, Hartley's *Summer Sea Window, Red
Curtain* of 1942 has turned his usually palpable cloud into
a Rothko rectangle, luminous and blurred.)

The devious path I have traced also and primarily
connects Hartley with the main, perhaps sole tradition of
"American" art, which was landscape painting. While the

Thomas Cole, *Landscape with Tree Trunks*, 1828.
Oil on canvas, 26 × 32¼"
Museum of Art,
Rhode Island School of Design,
Providence, R.I.,
Walter A. Kimball Fund.

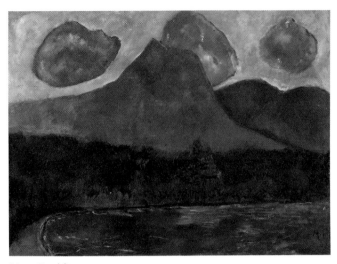

Mount Katahdin, 1942.
Oil on board, 30 × 40"
National Gallery of Art,
Washington D.C.
Gift of Mrs. Mellon Byers, 1970.

French followed their revolution with history paintings of heroic Roman subjects, the Americans (after the usual propaganda pieces) rejected the European tradition of figure painting for landscape. This tradition connects Washington Allston and Thomas Cole with Jackson Pollock and Willem de Kooning, and, art historians have argued, is the American precedent for the total-field paintings of the Abstract Expressionists. Cole and de Kooning, however, have in common with Hartley the virtual interchangeability of human (Hartley's totemic or votive) and landscape images. De Kooning has been known to turn one of his Women on its side and make it into a landscape; and these representations, women and landscapes, are his primary ones. Cole's landscape, as Bryan Wolf has shown, presents a threatening, paternal mountain, before which is a small promontory from which we as spectator challenge the mountain but see no way across the abyss to make common cause with it. The landscape became, I suspect, the way the American image-makers joined their endless plains, forests and mountains with their original revolutionary images of themselves as sons rebelling against a father—England, George III, any authority figure—while at the same time repressing for themselves the distressing reality of a revolution on the French model.

Hartley's Katahdin rises from the gentle slope of middle-ground which separates a lake in the foreground from the cloud-spotted sky. The hills beyond serve to

blunt and soften the precedence of Katahdin. In one painting of 1941 the mountain is submerged in a range and returns to the roughly horizontal line of the earliest Maine scenes. The clouds above are the same color and texture as the mountain, and the formal relationships are less those of Cole's sublime landscape than the interplay of the mountain shape rising through the parallel lines of horizon and rocky shore in *Evening Storm* and the seascapes. But only now the area at the bottom is an open mouth of a lake and the emphasis is on the rising mountain shape.

Nevertheless the phallic, threatening figure is the subject. Though a great deal is made of total-field painting by the successors of the Abstract Expressionists, in fact for the masters themselves it was a passing phase of short duration. Nor was it the mode of all the masters of that generation, for example Rothko, Kline, and Gottlieb. Pollock began with paint swirls that gather into a shape and stand out from the rest, and he returns to these forms in the single or double figures of his last paintings. De Kooning of course develops from over-all field paintings into the Women and Landscapes of the 1950s in which the central shape, the anchor, is eyes-nose-mouth or breasts or pelvis, and landscapes in which it is an intersection or connection of a similar sort, as basically sexual as the Women. It is significant that de Kooning's interchangeable Women and Landscapes are equally threatening—each a version of something as ambitious as the great white whale. De Kooning's women are in this sense in the tradition of Hartley's votive Madonnas, his War Motifs with their phallic shapes topped with plumed helmets and soldiers' tents, and his archaic portraits of Ryder and other "American" heroes—as Hartley shows, the alternative to the landscape tradition, in which a broad expanse of sea is devouring, or a mountain rises threatening in the distance.

In the case of Hartley as in the cases of Rothko, de Kooning, and the Abstract Expressionists there is the same search for the one summary symbol, the single all-expressive image, which for Hartley, who remains within the representational mode, is a series of mountain and sea scapes. Shared also is the need to see these final images as the culmination of a series of trials or, in a single painting, of constant revision, a sense of process rather than product, an effort shown in action by Pollock and de Kooning. In the next generation scale becomes the additional factor, the modello is blown up into the Orozco mural. With Pollock and de Kooning it is the infinite expansion in search of the one word, which takes

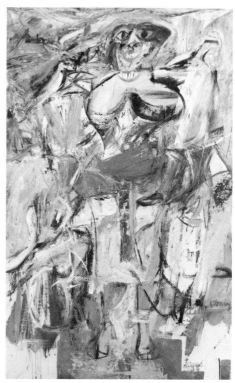

Willem de Kooning, *Woman and Bicycle*, 1952-53. Oil on canvas, 76½ × 49" Whitney Museum of American Art, New York.

the form of size or the expansion of an incident into a kind of unbounded inter-relatedness of all things, as a de Kooning image shifts from woman to landscape, from mouth to mailbox. For total knowledge of one of these paintings both beginning and ending have to be charted. Pollock has to film the process of a painting or de Kooning has to tell us—or include in his paintings—his total process from beginning to end including the thumb tacks and bits of rotated paper. If for these painters process has taken on the sense of palimpsest, or a series of layers in a limited space, this is only one dimension of the longer process in time as one painting of a woman follows another. Either a single woman is built up out of many shapes of women and other things or she is repeated with variations on canvas after canvas. But in both a very strong sense of a series in time—either the walls surrounded by an unending scrawl along the line of Monet's Waterlilies, or the walls hung with endless separate icons by Rothko or Gottlieb or Kline intended as an environment. Among other things, the idea of the single masterwork disappears in a process that shows the artist developing or extending himself in time as well as space. This, I am suggesting, points up the importance of the pilgrimage of Hartley from Maine to Europe and back to Maine as represented in the series of paintings that registered his search.

One form taken by all of these artists, as they developed into the artists of the late 1940s breakthrough, was the return to primitive, totemic expression. It was the social content of such primitivism that was emphasized, and both connected with the free American landscape, which now appeared to be in the process of being corrupted. And if one form this primitivism took was vaguely totemic forms, later reduced to even simpler, less representational shapes, another was the process of reduction itself—whether shown in a single canvas or in a series of trials and errors.

Partly as a way of expressing the self, the artists in question went back to psychoanalysis, in particular to Jungian archetypes, reached in most cases through the surrealist movement, and in almost every case these artists arrived at their so-called breakthrough style or image by employing a combination of Cubism and Surrealism, leading to a reaction against the one and an adaptation of the automaticism and the representations of what were taken to be totems and sexual or fertility symbols of the other. The process continued with a gradual purging or simplifying of these totems or Moby Dick-like symbols until—as in Melville's famous chapter—only the whiteness, or the essential image

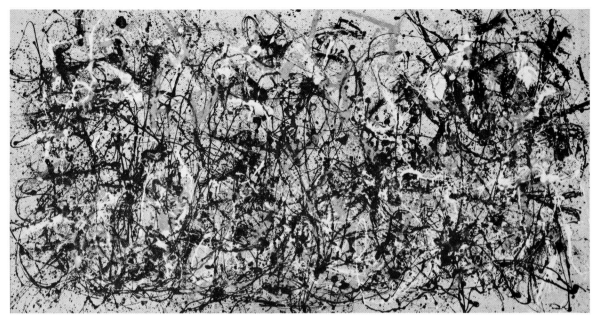

Jackson Pollock, *Autumn Rhythm*, 1957.
Oil on canvas, 105 × 207″
The Metropolitan Museum of Art,
New York
George A. Hearn Fund,
1957.

remained: the horizontal demarcations of Rothko, the larger interlooping swaths of Pollock, the vertical lines of Still and Newman, the gigantic ideograms of Kline. This was a search for the ultimate hieroglyph which ended, as in Poe's *Arthur Gordon Pym*, in utter whiteness or blackness, or in a glowing, powerfully evocative image like Rothko's. One of the reasons Hartley is important for us is that he lays out the terms, works out the images, and employs the particular combination of social and personal, surrealist and psychological that informs the reduction to the most basic essentials.

Notes
1. A somewhat different version of this essay first appeared as a review of the 1980 Hartley exhibition at the Whitney Museum: *Bennington Review,* September 1980, pp. 63-68.

2. Haskell, *Marsden Hartley* (New York: Whitney Museum of American Art and New York University Press, 1980), p. 12. My Hartley citations are from Haskell's introduction and catalogue.

3. Porter, *Art on its Own Terms,* ed. Rackstraw Downes (New York, 1979), p. 56.

4. My quotations are from William Howarth's edition of *The Maine Woods* (1864) in *Thoreau in the Mountains* (New York: Farrar, Straus, Giroux, 1982)

5. See Wolf, *Romantic Re-Vision* (University of Chicago Press, 1982), chap.5.

Jackson Pollock, *No. 29,* 1950.
Oil and other material on glass, 48 × 72″
The National Gallery of Canada,
Ottawa.

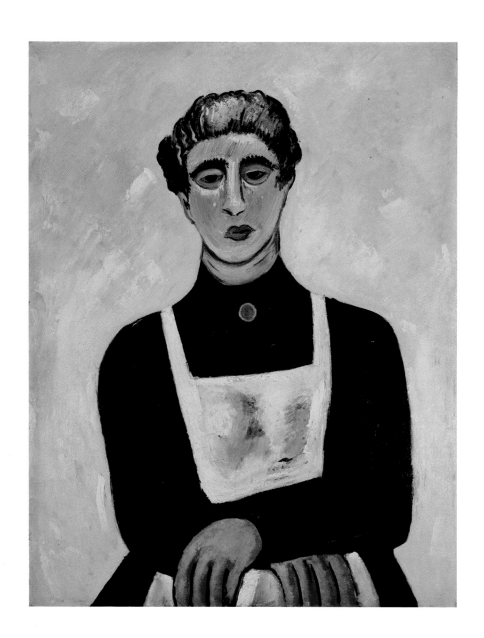

Plate 3
Marie Ste. Esprit, 1938-39.
Oil on board, 30 × 24"
University Art Museum,
University of Minnesota, Minneapolis;
Bequest of Hudson Walker from the Ione
and Hudson Walker Collection.

Letters From Marsden Hartley
To Adelaide Kuntz (1935-1936)

1935

Blue Rocks
Nova Scotia
Sunday eve
Oct. 6. 35

My dear Adelaide,

Nice name, don't you think, & on such a stark but solid looking fishing village—two churches and a school—and a jigsaw coast. The journey up from Boston to Yarmouth delightful, the smartest little boat—so clean & so busy getting there she was, and excellent food though a bit dear. The all day train ride up from Yarmouth to Lunenburg was so nice in boat flavors—a nice crew of fellows in smoker on train, all natives on way home from a long job up the line—good natured people the NSers are. Reached Lunenburg finally at 4:15—eight hours on way—to find my friend Davison had left for Halifax the day before. I stayed a week in Lunenburg—couldn't like it —such a curiously gauche place though people are very genial, but all so [illegible word] and the most German names ever imaginable—Zwick, Zwicker, Knickle, Knaulbach, Eisner, etc. and none of em speak German or know a word of it & yet so many of them have thick, low German accents—not a word of German do they understand.

The taxi man at station said, You must come over to Blue Rocks—lovely there—so after a week of boredom in "elegant" tourist house—cold as a barn as far as hospitality went—stingy with food—though all the flourishes—low beds at 12 a week. So I walked out here & in to this dear little house—such a sweet family—far more cultivated than the average. You'd love them— especially the mother. I fell for her at once—a pretty, shy little thing—a mother of four grown sons and daughters—oldest 27—youngest 14. The two sons home—very handsome & nice boys—make good company for me—all jovial, bright, witty—quite the reverse from what I expected, but they are all genial

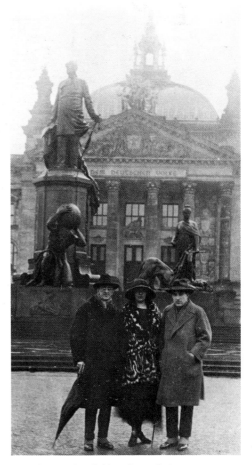

Marsden Hartley (left) with Frank Davison (right)—woman unidentified — in front of the Reichstag, Berlin, ca 1923.

The Leander Knickle house, Blue Rocks.

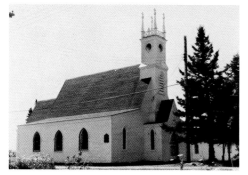

St. Barnabas Anglican Church, Blue Rocks.

round these shores. The houses sit around on the edges of inlets and the sea is fifty feet from this one—it being one of the oldest here, with a bay window above the door and two rows of conch shells from the Indies down the steps. I sleep in feathers and like em, and am sleeping much better, and o, the crayon portraits, the seashell frames, hooked rugs & braided ones, and a reed organ on which Leander Knickle (Papa) played & sang me "Beautiful Isles of somewhere" first evening—a right jolly sweet home, & I have learned all about this part of Nova Scotia—in 24 hours. I had the whole story, for their Aunt Nellie is a marvelous type with parchment skin and a violent mania for the truth and she talked a blue streak at first for me probably—anyhow all about the trouble with the rector of their church, St. Barnabas Church of England, and wishing he'd go somewhere else, & Bishop says if he can't get on with the parish he can't have one, & so he is now preaching to empty seats. One day four old girls came—two in a motorboat from across the bay, & they all spun Mrs. Knickle's wool up & talked—one was 74 the others fifty odd. What flavors it all gave— everything in it that this German locality would have & so strange—not one of 'em speaks German or understands a word & yet they all have thick accents.

But it is a salt of the earth country & so good to get down to earth and its true values again—very primitive of course. The well up in one corner of the field & the "comfort station" in another, bowl and pitcher in room of course, but o, so honest to God, all of it. They have a marvelous cow who all but churns her own butter— cream is so thick—all bread, cake and cookies so good, and the dearest woman who makes them—and love rules this house—and though they are pious they are not boring about it, but no scandal or [illegible word] talk & plenty of fun. Leander, Papa Knickle, got his traps last night & caught four lobsters, all for me although law is on[e], but I being stranger he wanted to do something special & so—all this good food & sweet company for $1.00 a day for everything, and life is sweet and wholesome

I'm so glad I came, and it is so good to be getting to sleep again & to have such intelligent companionship, for they are all bright [and] all went through high school— mother taught school 9 years, so talk is never silly or stupid or forced. So I feel it was well worth the time & the money to get this far, and all so wholesome and natural.

Men are all husky & handsome—women husky & not handsome, but they do hard work. Men all fishermen &

look so contented, [to be] home off the Banks and safe in
their own snug harbours

Love,
Marsden

October 16. 35
Blue Rocks, Nova Scotia

My dear Adelaide,

. . . A magnificent specimen of a man was here for noon
meal today—young—28—perfect giant—soft voice
lovely English (& the English here is excellent at best) he
& his brother local giants—build boats, do all their own
black smithing & all that—superb specimens, with
doubtless a dash of "Canuck" on father's side though the
name is Mason, the mother local German—probably
hadn't been home since election two days ago—came in
drunk & drank lots more—hugged us all round like a
Gorilla—& was generally good natured
 So you see I'm in a wild country, but I am being so
gradually taken in here though they are shy—classical in
their fierce looks, they melt after a time & smile & I feel
one of them already. I can always make my social grade
in places like this where raw truth counts more than
smooth manners, and I get taken in by the men as a pal,
especially this sort, & they are such salts of the earth.
They are all home now off the sea & look so grateful that
the sea let them come home to their families once more,
for they never know. Ten days ago a ship went down off
Cape Breton, & after a terrible siege at sea in dories
those still alive managed to row into shore. One of them
crawled on his hands & knees up to a house, & they
rescued those. The others perished & were washed
ashore last week. But they dread the sea terribly, & they
are the real thing here. No "dude" fishermen around
here. Leander, the dear old lad, hauled me 4 lobsters the
other night (law being one now) & is going to get me
some more, but I have warned him to take no risks just
to be nice to me. The other day Robert and I went over to
an island & brought home a half bushel of clams, and
during the week two small boats down in a cove go out
fishing and I got a huge 8 lb. codfish & brought it home
for 10¢, & so lovely and fresh.
 You'd love these people. None better. Rock bottom
sort. No frills, but so tender underneath. Rough
exteriors, & then Mrs. K is such a dear. I fell for her the

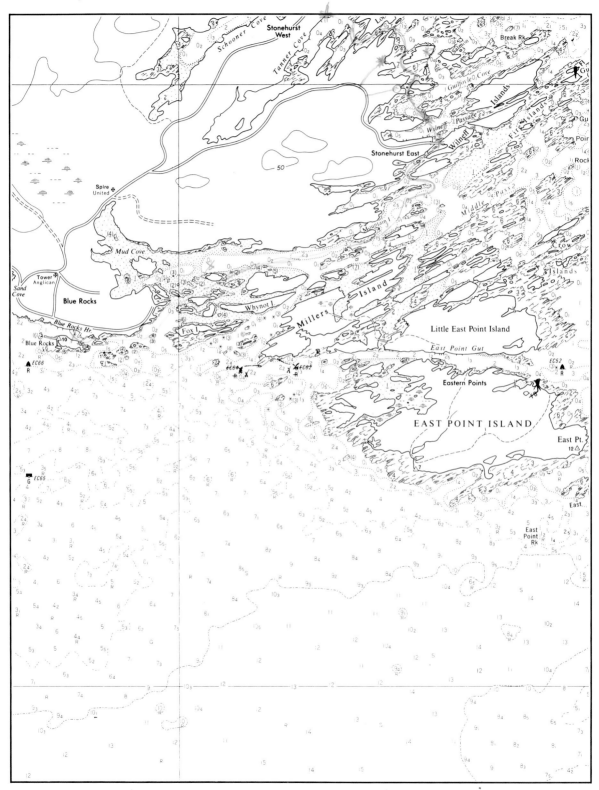

Detail from a nautical chart of Lunenburg Bay, Nova Scotia.

day I came. Generally a good cook. Poor dear falls down on pies for her crusts are too heavy, but she bakes all her own bread, cake, cookies, makes her own butter—even makes me a special pat without salt, and it is years since I have seen or eaten such thick cream, they having such a wonderful cow.

Leander has just come in smiling, saying gov't inspector was just here, looked over his salt mackerel, pronounced them excellent and stamped them. They all run and tell everything and I love it.

I hope one day to be able to do all of this whole coast and drop into such little eyries as this all along—get into the Scotch of it up at Cape Breton and Antigonish and then the Norman French up the Gaspé way. It's lovely to think there's somewhere to go on this side of the ocean and still get the true flavors of the old rich wines of life, and there is a lot of old vintage quality left up this way

Devotedly,
Marsden

Eastern Points
Lunenburg
N.S.
Nov. 4. 35

My dear Adelaide,

. . . I came up last night in the moonlight to Eastern Points to stay the rest of the time—or three weeks more because I fell in love with the most amazing family of men & women the like of which I have never in my life seen—veritable rocks of Gibraltar in appearance, the very salt of salt. How I would love to paint a series of them all & would try save that I would be involved as Cézanne was with his Vollard portrait which took 80 sittings.

These Francis Mason folks are simply wonderful. God, what men & the women suited to them. When I came up last week for the day to see the speedboat the two giant sons are building I was swept away by the tidal forces of their humanism, and the two boys nearly devoured me with affectionate devotion. Donald—or Donny—is 31 & looks much like the youngest, and Alty (Alton) is 28. They were in town for two days—drunk at election time, and I didn't want any drink that day, but I said to Alty that next time I saw him I would take a good

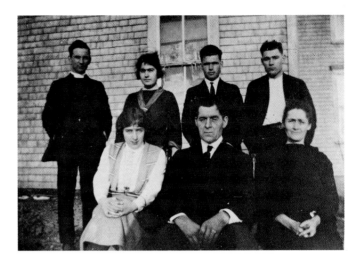

Francis Mason family, ca 1930. (from left to right) front row: Cousin Derrell Mason, Francis, Martha. Back row: unidentified minister, Alice, Donny, Alty. Collection of Edwin Mason.

drink with him—and being drunk—& both of them are divine when they are drunk (& terribly shy when they are sober) I thought he would forget it—but not at all. The first thing he said was you promised me you'd drink with me—so of course I said sure, & so we were all inside the speedboat before she was launched—seven fishermen & what a lovely time it was.

So I asked them to take me to board the rest of my stay so I could widen the scope of my vision of this country. It is an island here—only a mile and a half from Blue Rocks, and is gorgeously wild with deep forests & the trees all hanging with grizzly moss, etc. and all still more secluded than Blue Rocks &d really is what I have been looking for, & I see my next summer here very easily and want to come back in April & stay to the end of November again.

I pay $7 a week for board up here, & really have the life I crave, and these people are like deep, flowing rivers, oceans, of lovingkindness and all so still & quiet. And as I say, the boys when drunk are divine & that is such a comfort, for I hate ugly drunks anywhere, and the boys want me to be here next summer and go fishing, & they have beside fishing boats—a gasoline launch, now a new speed-boat, small boats, and a car. And they would ride me round all the time & be such good warm playmates—& they crave it so too—it's nice being the mystery wonder, the magical person in places like this for they are so humble &d they are so grateful for attention from the outside world, of which they get very little naturally. It has been a sweet revelation to be among these completely humble people, and I wish I could do something for them such as play a guitar & sing for they never have anything of that kind. O, so true & real like the sea & the rocks.

Mrs. Mason is Germanic with an accent, & Mr. is without question Canadian French, so dark and rugged he is & the boys also. All of them look like cinnamon bears, & are terrifyingly powerful, & so quiet & childlike. I feel as if I had found my chosen people

Alty insists that next winter he will come down to N.Y. in his speedboat & see me, but, said he "You wouldn't look at a guy like me when you are in N.Y. City." So of course I had to be quick & say the right thing, & it is the one time in my life when my social style is correct, is when I am among just such people, and it is a style, for you must never patronize or say foolish, unmeant things

And it has been so worth coming for to know folks like Leander and Libby Knickle & now Francis and Martha Mason. My whole summer has been so rich in the human sense, for the Bermuda folks were so affectionate & endearing and loved to be loved as you must surmise. Here all live to be made a fuss over somehow. No end to hooked rugs and anti-macassars here in this house, and pinpoint [illegible word] —as well as the hardest bed I ever attempted to sleep on in my life, but I grit my teeth last night & went to it & slept seven hours without waking & was up at seven. This sort of life makes one show his fibres, but I must say I like feathers next to my back in preference to hay which this mattress is. There is a touch of Christian martyrdom about this life anyhow for they endure such hardships and hate any show of cheap affections ■

As for the harrowing tales of the sea they all tell without any attempt of show, well it stirs the bones of pity, & when I see Francis Mason with his majestic face lean over the table & say grace, "O, God, we thank Thee, etc" I feel so honored to be among them.

Think of me as being completely happy in the arms of the Mason family. You'd love them too, & you would certainly Leander and Libby. Yesterday Leander & I had a little Church of E by ourselves—he plays organ so well & I have a nice voice & know C of E forms perfectly. Too bad they are unhappy with the Rector here & they want him to go, but can't fire him as they are a mission church ♭ & have no say—but they are freezing him out slowly, and as a telling & vital symbol they turned over his privy on Halloween night. He fool-like, calls up the "Mounties" in Lunenburg (Canadian Mounted Police) saying there were troubles over this way. They came & laughed in his face.

Devotedly,
Marsden

Undated letter, 1935:

Papa Mason is French—hence the dark complexion, the quick minds and the big bodies. From him they get clarity and honour—from her they get industry and moral force—and there is a pontifical quality about everything they do. An evening at home here is almost mountainous in its impact.

 Alty is a crack mechanic. Donny is likewise capable. They are carpenters, boatbuilders, blacksmiths, fishermen—in all branches, so I get fine things to look at all the time. The new speedboat just finished, rides the sea like a porpoise. But they are not satisfied with her speed as yet. She must do 12 to 14 an hour or she's no good.

 . . . The women carry all the wood and water here. Alice, the daughter, is a giant and takes a double armful like toys. She's bigger than Alty or Donny, and has an Amazon body. Of course she is the symbol of protection for the family as mother and father are on the decline, and boys show no signs of marrying—or Alice either

Love,
Marsden

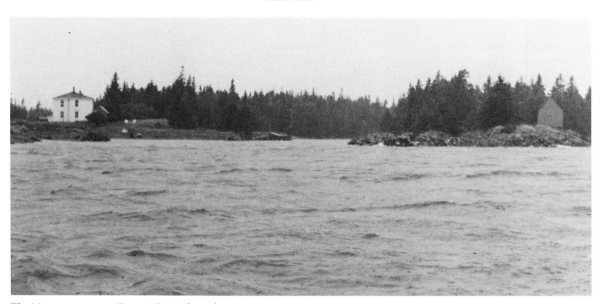

The Mason property at Eastern Points from the Gut which separates East Point Island from Little East Point Island. The Mason house and the fish house were connected by a footbridge until the early 1950's.

Eastern Points
Lunenburg
Nov 6. 35

Dear Adelaide,

I know I shall come back here next spring—all this vital
energy & force is too good to miss, and I have never been
so near the real thing before, for a fisherman is more of a
'thing' than a shut-in farmer—that is a N.E. one, and it's
all so new to me & enveloping. I shifted over here to
Eastern Points 1¼ miles from Blue Rocks, because the
magnets that drew me were so strong—first of all the
mother—one of the four who came to spin the day after I
landed in Blue Rocks—then the two giant sons that walk
& look like bruins & are sweet and gentle as lambs & so
affectionate—they fell for me hard, both of them, each ✹
whispering in secret, so to speak, his affections &
offering lures to get me to come back—tuna fishing & all
that so I'm already steering this way next March. I
want to get back to pick Mayflowers, or arbutus. Haven't
done that since I was a child—and as I get rich good food
& beautiful society, I want all I can get of it, and I have
peace & quiet here, no worries, and no battles with costs
of living. There is little or nothing to spend money for, so
I can live easily on $35 a month here, and have a grand
time. I could even have a tent & live in the woods and
that would be fun & get my meals here—& such good
wholesome cooking & such grand people to look at. Two
days and I'm not yet used to their wild beauty, their
sweet characters, & their good brains for they are above
the average—all these people and not at all ingrown or
inhibited which is delightful.

Leander Knickle says that Alty (Alton Mason) is
"dead gone on me" which is cute, and I haven't heard that
phrase since I was a kid myself and used it. Well I love
both Alty & Donny, & if I were a woman I'd have a time
choosing—for Alty is wild and all flair, all demonstrative.
Donny is shy as a thrush and never ventures out of the
deep forests of his being until he is sure he is safe—but
being a man I have them both in the ways men have of
being for each other, & it's all lovely, & I assure you, if I
did murals, I'd do one of the family at supper or noon
meal. The table is long and narrow. I'm in the center,
Donny right, Alty left, and sister on the other side—
walls blue, furniture black—Mama always in black with
white apron—boys & Papa in overalls and dark & mystic
looking. Already I even think of doing studies of the men
next year, though if I stayed the winter I could do it now
as this is the slack time & they are only mending nets
now & puttering around. I do wish you could see the

people—too remarkable really & so quiet

And so I can see myself making a kind of itinerary between North Carolina for some of the winter—New York for a few weeks & then up here, and I could draw such life from it—Thereby become more alive myself—therefore more attractive to myself & others—therefore more eligible for society. I haven't liked myself for some time now, because I don't like to hate for it is bad for the soul and unhealthy for the body, and I'm capable of loving hard & strong, so I must become violently in love again. I want life to speak out and say—how you have changed—what a boy—welcome home. I don't want escape via intellectual ruses. I want affirmations via passionate embraces—& you can't have life unless you give it. Anyhow, I left the blacksmith shop to come and write this & must go back & see what the boys are doing. All so ample and provident here—bags and bags of grain, coils and coils of rope, lovely smell of tar and shavings—& the grey light shining through windows on carpenters tools and odd objects and bottles

Love,
Marsden

1936

From a letter dated July 29, 1936, describing his journey up the New Brunswick coast and across Nova Scotia to Halifax:

. . . I wish I could go so many places just now, for I have such a [?] for sudden new vision for writing perhaps, and this trying to paint and write at the same time still disturbs , and I am always hoping to get them to flow serenely one into another, but do not feel I have succeeded for painting is in a sense a mechanical thing and calls for settled states, but writing can be done as one goes, and I envy the writers that much that when they want to work all they need is pencil and pen and something to sit on. Yet I always thank the heavens I am not a sculptor for the labor and the cost of that art are terrific and shackling in the bargain. By the time I got here with my trail of packages, 12 in number, 8 of which I have to juggle myself from train to train as there were no porters, I felt as if I had had enough of the painting job

E.P.
Lunenburg Co
Canada
Sept 9 36

Dear Adelaide,

. . . And if my summer has been & will be at least a three dimensional drawing with hints of a fourth, I have been more than content with it, even if at moments I may have wished to escape from this orchestral simplicity and nobility of this home. I have never known people like them—never, & I doubt if any other exists—even in their own community they are looked up to with great admiration which is a test of anyone's worth really.

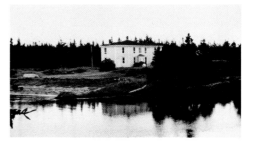

The Mason home was a two-family house built by Francis and his brother Arthur.

My beloved Cleophas (invented name for writing purposes) with his seventy years, so full of faith, youth & love—is a constant inspiration to me and if Aunt Martha—for whom I must find a name—is a close second to him with her practical mysticism underlying everything she does—well, they are simply not to be beaten. I never tire of them and can't imagine myself ever doing so. They are so utterly & completely free of neuroses of any sort, and maintain an enviable balance between the material & the spiritual worlds that they symbolize for me the term, ideal. They love each other & you feel they were sent to each other from the beginning. And their four giantesque children—two sons and two daughters—a third giant son who died—the biggest of them all—at 23 of pneumonia. Every one of 'em like rocks from which fresh springs flow without hindrance.

Of course the four children have slight neuroses, for none of them are married, and it is not likely three of them ever will. No one comes for them, & they are not the kind to run after. The fourth is the most naturally lovingest, but he has picked out a tiny sprightly little [wren?] school teacher—& they are delightful to look at—he like a dark hemlock & she like a yellow finch perched in his branches. But I fear doom is there because she looks as if she might blow away like a thistledown any minute & would be no good at all as a fisherman's wife for they must be sturdy, and as to strength something like men.

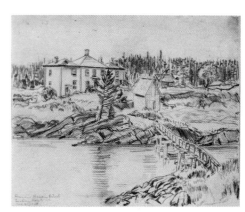

Larry Brannen. *Francis Mason Estate*, Aug. 21, 1948. Present whereabouts unknown. View from the fish house, which Hartley used as a studio, toward the Mason house. Beyond the footbridge is the ice house and in the right background, the blacksmith shop.

So they all sit evenings and rock while I sit in the parlour among the crayon portraits &d chromis and keep the radio going which is a favorite here. They all enjoy it and we get Hollywood and the Lux Theater program on Mondays, Bruna Castagna and the new contralto of the Met Op on Saturdays, and a lovely new fresh voice she has—deep [illegible word] and reminds of my greatest

passion in world's voices that of the late Maria Delna.

Saturday night last it was James Cagney and Robert Armstrong doing excerpts from the Prize Fight [illegible word] and Is that So—both of em so flavorish in that line of stuff

As the men cling to each other of course so do the boys, and platonic friendship is evident between all ages. A boy of seventeen will hug a man of fifty or more and caresses are exchanged. Of course they go to sea together—and the fisherman of 17 is just as much a unit & gets his share of the profits &d losses as does his father or maybe grandfather. So it makes them into men as soon as they can row a dory

It is hard to live up to at times in localities like these, for they make a symbol of perfection of one at once & no one can fulfill such exactions, so I have to offset it by adding rabelaisian touches such as they like to find relief in, & that pins me down to earth with them & they find me a regular fellow in the end

And so I go on. And Cleophas would have me build a shack, & even Alphonse Adelard (invented name) says, lets you & me build a shack here & live in it—which means it could be built cheaply as I am sure they would contribute the labor if I would buy the lumber, with the only condition that I were to live in it as much as I pleased—theirs when I left for good. I could then have a summer home for $60 or $75—just for the lumber—but I do know if & when I shall be coming again. I *know* I will be coming again because love of Cleophas is a strong magnet & would draw me as long as he lived, and the others would draw me too

I paint in rich low key and for the first time have really been identified with the sea & here they call me a good seaman. I climb in & out of dories & fishing boats as well as they do.

Devotedly
M.

46

Sept. 23-36

Dearest Adelaide,

I don't want to tell what I have to tell, but a terrible
tragedy has fallen on our home here, & the two big
lovely boys of the family & their pretty young cousin
were drown Saturday night in the teeth of the gale that
swept up from Florida all along the Atlantic seaboard
struck us here sometime during the night, blew all day at
surely nothing less than 75 miles an hour with blinding
sheets of rain. At about six in the evening it subsided a
little, but then was still enough of it to call a hard wind.

 The boys were in the habit of coming down Saturday
night for over Sunday as two of them worked in
Lunenburg during the week and the other one was in
town & so they had come down together Sunday
morning. It was as lovely as if nothing had happened—
bright sunshine and hardly a breeze, and we all said,
what a heavenly morning (little dreaming). When the
boys didn't come home, they thought they would have
stayed over night at Leander's as they had done before,
& some of the men went over to the mainland—mind
you only a mile and a half away, and the first tell-tale
facts were that their car was in the garage, and their
punt which lay on the shore during the week and in
which they would row home, was nowhere in sight.

 They sometimes drank heavily, and I thought maybe
they all had got drunk & had gone off on a bat with
some of the shore boys, but Aunt Martha said they
never stayed away Sundays for they loved to be home.

 Well, it all came to a head and the punt was found 20
miles down shore with some things in it and no paddles
or oars, and the rest has come to light & they are lost
within five minutes of home. The shore is terribly jagged
just here, and even I used to wonder how they could
know the submerged rocks so well and in the dark, for I
have gone to church with them so often on Sunday
evenings over on the mainland, and as it was the single
event of the week, it was a gay event going over to
church, & one felt so utterly safe because they were
completely reliable at the wheel, all of them.

 How many times had Alty the strongest and most
theatric been warned that he would one day come to
grief by his dare-devilishness, but he hadn't the trace of
fear about anything, but poor dear Francis, the father,
feels so badly that Alty should have had so little sense of
judgment, being a completely experienced seaman, & the
men all say they would have had a hard time trying to
get down, even in a gasoline boat as the gale was blowing
hard & nothing could have lived in it.

The theory is they lost their oars & so decided to jump out & swim, and because pretty little Allen was the youngest (19) and the weakest, they stuck to him, and they either got dashed against the rocks, or they were pulled under by the swell.

O, how hard it has been & still is, but for two days, I had to go over to the neighbors as I couldn't sit here & see the silent agony of poor dear Francis & Martha, & what fate has been theirs to lose their four sons, two at each time—the other two some years ago with flu.

But o, they are so strong and courageous and noble, and in some ways I almost hope they won't find the boys, as it would have to be lived all over again.

I have always wondered at the sweetness of these people in general for theirs is a hard life, but death at sea is part of their experience for generations, and so I suppose therefore this quiet acceptance of it.

But if our boys had been out fishing on the "Banks" & the ship had gone down with all hands, that would be somehow in the picture of life here, but it was nothing but foolishness and I must blame no one but Alty because he was so utterly fearless & not always sound in his judgments and all just off shore not five minutes from several safety spots. Well, it's done, but o, the wrench, even to me who had grown to love them dearly & been so proud to know them, and being the more or less "exotic" stranger, they gave me special attention, just because I was not one of them in the regular sense

I thought perhaps I might go, but Ruby, the daughter who is a very attractive woman and extremely smart looking and wears the very best of clothes has been secretary in an insurance office in Halifax for some years—said, o no—it would be nice if I could stay as it would be a strength to them, and I couldn't bear the symbol of disappearing in a dark moment, so I shall stay as a guest the same.

O I do almost hope they won't find the boys and there is little hope they will for the undertow is strong around these rocks, though of course they all talk of "nice days" and it could be months or never.

Foolhardy Alty—so loveable & so terrific—so affectionate, so theatric—dear, sweet gentle, lyrical Donny who never had a dark thought or an exaggerated one about anything, has left his little goldfinch girl in misery as they were heading strong towards marriage and another life. Well we all learn how tragic the moment can be when poise & judgment fail.

The sea outside the door now might be a quiet little pool in a green meadow—it is so calm—

Ruby Mason (left) and Alice Mason (right) with their island friends, ca 1930.

I admire the strength of these plain people, but I suppose it is merely the material pattern of their kind of life that makes them sturdy and rugged without trying to be.

I wish this letter were not so sad, but I had to tell someone for it has lacerated me too in my way, for the boys were the quintessence of manly beauty & strength and joy. Never have I known anyone like them. Never a mean thought or act, drunk or sober, & their only fault was drinking now & then. They were fond of me &d I loved them, & they had such good sense about other things than the [fatal?] one.

Devotedly,
Marsden

Eastern Points
Oct 5-36.

Dearest Adelaide,

How immeasurably good of you to write me such a comforting letter—and with a very tender one from the Rev Harry J. Knickle of Holy Trinity (East 88th Street, 2nd Ave) who is a native son of Blue Rocks and a very nice person I felt my sorrow to be more distinguished.

It has been the hardest two weeks I have ever encountered, for I had to show my powers to help these dear people support their burden, and I had my own loss to support, and now that everything is over in the ceremonial sense there is the truth to get used to, and it is awful. I can't help but say it—awful.

I know what it was when it came to you, and it is hard to reconcile oneself. I know it might seem strange to some to think it could mean so much to me, but after all friendship is a kind of marriage as we all know and a rich fund of natural associations was being built up here as a result of that rare relation I have had with this family, and as I have said before, I have never known anyone like them, for singly they were so magnetic and en famille— well as you can imagine evenings and mealtimes with all that wealth of glowing humanity about—never a cross or even a sharp word among the five of them—not a trace of domestic neurosis—nobody wanting to escape anyone else—no one outwardly demonstrative—that is among themselves—but a deep river of love running through them all. I was probably the chief recipient of the boys' outbursts of affections as I was of course the

C. Alton Mason, ca 1935. Photo by Knickle Studio, Lunenburg; Collection of Richard Mason.

romantic stranger in their midst—the mystical image for them as men. As boys they were always delightful and they had preserved so much of adolescent freshness in their behaviors and besides by inheritance, vastly different from all others around here. They had magnificent physiques—something like genius in mechanical pursuits and a real capacity for affection and lovingkindness. They were never tiresome, never banal, never common, never gross about the house, never any oaths in the presence of their parents—a higher respect for duty and an appealing sense of remorse for their "evil" ways which was the single one of drinking

You would have loved them too, dear Adelaide, with your sense of real human beings . . . Alty's hair black & standing six inches above eyebrows straight up like charged wire or the wig of a clown, simply because it wouldn't lie down. Donny was extremely beautiful in countenance with his sea oil clothes on—well, picture perfect really. And so it is I have had a constant source of enjoyment in the different styles of these personalities—each of them with their own type of invented English—none of them speaking in the superb diction and the tone of Papa Francis who looks & sounds like a great Shakespearean actor or a dark angel of Blake's.

I wanted to see them for a long time & then attempt a series of invented portraits of them, and I do not give up this idea even now.

Dear Donny came to the surface finally last Tuesday morning, and if I had gone in the boat that was on its way to town I would have been subjected to the awful experience of seeing him since being described to me abjectly—disfigured, as was poor little Allen also—less in Alty's case they said. We were spared all this by the great strength of dear Papa Francis or Cleophas who went straight to his problem, looked on the boys & said they must go at once to the undertaker. Being soft about such things I was terrified lest the mother instinct would prevail & the boys would be brought home, and as my room is off the parlour, you can imagine—I would have had to go over to the mainland, but the woman accepted the undertaker's verdict, & they were not seen by any of us over here. The descriptions were enough. So with Donny's appearance it had to be all gone through again. That was last Wednesday. Yesterday in Lunenburg it was Memorial Day for the fishermen lost at sea during the year—it was most impressive—a double choir of fifty and perhaps 2000 people out around the bandstand— good singing—good band—five clergymen—then the procession to the docks to cast a wreath and an anchor of flowers in the waters. I had wanted to see this ceremony

for years as they have it under R.C. auspices in Gloucester—therefore even richer with crucifix, banners, incense and all that, but as Protestant form it was really very good

Well today I have felt sort of flat, so I have not painted—took a walk around the edge of the island, picked up more pebbles, listened to the sea, and thought, o, how I miss the boys really—and what is it that makes such things right? Their places are never taken. Their style of love and trust is never duplicated. All they can do is become treasured images, I suppose, and gain their known immortality that way.

It has been like that in varying degrees with four I have lost since 1914 or the war period

But I have enjoyed my summer and the beautiful effects of looking constantly at the horizon of the sea has been psychically very valuable because it represents extension and not the aspirational of the vertical or as much, and I am sure that is one thing that tires the more sensitive ones in N.Y.—the fact that vertical lines hem one in everywhere, & that for the most part there is no horizon at all. A horizontal line is basic at all events, whereas vertical represents action.

This must be a letter by now. I hope it is. I have sat quietly in my fishhouse studio & heard nothing but the sea.

Devotedly
Marsden

Fishermen's Memorial Service, Lunenburg, Nova Scotia.

Eastern Points
Lunenburg Co.
Oct 30.36.

My dear Adelaide—

Great relief this morning after yesterday which was dreadful. Rained the entire day and everything soggy as a cake, which even the chickens couldn't eat. Today it is as soft as spring and as gentle, and what a difference it makes to one's feelings to have the sun, at any time—and for us who have gone through so much, o so much more than was deserved, we are glad for every warm ray of it.

And there is always the almost more poignant aftermath to contend with—when the thing itself persists in the immediate drama, thus these countless little reminders during the day when the boys are bound to appear so vividly at one's side here—not a day—not an

hour when I do not feel nature has been so cruelly discounted, and in all truth, so cruelly deprived, for they were among the very choicest of nature's gifts, & we should not have taken from us what was so grandly given.

I have been working on my last efforts—two wild ducks which I so wanted &d were brought me thoughtfully by one of the couriers and I am working on them in the blacksmith's shop because it is now particularly so quiet—no hammers, no anvil tones, no blustering boys, no rich thick flavors of manly energy in labour there which made last year such a social delight and privilege. I wondered if I could endure the vacant space, but like the lady in *Morning Becomes Electra*, who on deciding to leave everything, stands in the outer steps and declares, "Now I can live here. I can live with the dead"—or almost those words, I decided I could work there, and if every plane and hammer, the anvil, the forge, the tool chest, and the general debris of such labours—all but shouted at me, I decided I could live with it all, and make them ring true again. And so after going in one day alone to test myself, the first shock being a little painful I decided I could make everything now so silent have life through associations of memory, and so I have managed to work there not too disturbed. And as no one comes in now, for nothing will be built again, I am alone with all the silent devices, and a kind of almost companionship emanates from them. And so the ducks are getting done—a black one with white top-knot red— & blue beak & orange legs—and another—white head & body with a wide band of brown black at the breast and steel blue feet. They are a test of observation, and what Marin calls the "piercing seeing of the object" is my special problem, and if I could have that piercing seeing of such subjects as the great Hordecoeter and that other Dutch enthusiast of mine Wilhem van Aelst—both of whom could do feathers as well as nature itself . . .

So my reading and writing and arithmetic of this season are about done now. All in all a profitable season, save for the tragedy—and I suppose one must learn to think of it too as somehow profitable—but oh, the pain and how that very marrow of the spine goes on aching with such deprivation—you know that too well yourself, else you couldn't have written me such an exquisite and precious epistle of sympathy.

I shall have a cluster of camera snaps of the boys and their folks in various poses when I return and will show them to you so you can have a sense of this amazing family—the like of which I have never encountered. Papa Francis is so like a prophet out of the Bible or Blake, and

Aunt Martha—she's sitting here now—rocking quietly Aunt Martha and Papa Francis are among the archangels on earth and I never expect to see or know anyone more thoroughly beautiful in every possible way, and I count the moments delicately now, as I must soon leave them—possibly to see them again—I certainly mean to, and would come up just for that—but if possibly not, then they have enriched my soul as no two others ever have, and I feel deeper and greater because of them.

If I could go through another six months with the boys gone I don't know, and now it seems neither plausible or necessary. They gave me fully of their deep rich manly affection, and I must live on it as we all must who are fated for love. The experience has been so rich, and if next summer is to be certainly more superficial and even trivial as it will be if I go to Santa Fe, I don't seem to mind it at all, for sometimes soufflé is agreeable after great dining and wining. I need to swing out too a little now, but I do have such a sense of home and relatedness—true relatedness—as perhaps never experienced before—save in earlier Germany perhaps

Devotedly,
Marsden

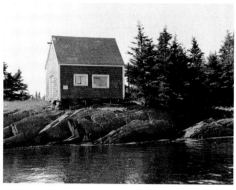

Hartley's fish house studio at Eastern Points.

Note
Microfilm copies of the correspondence between Marsden Hartley and Adelaide Kuntz are found in the Archives of American Art and in the Yale Collection of American Literature, Beinecke Rare Book and Manuscript Library, Yale University. This correspondence is published with the kind permission of the heirs of Adelaide Kuntz and Yale University.

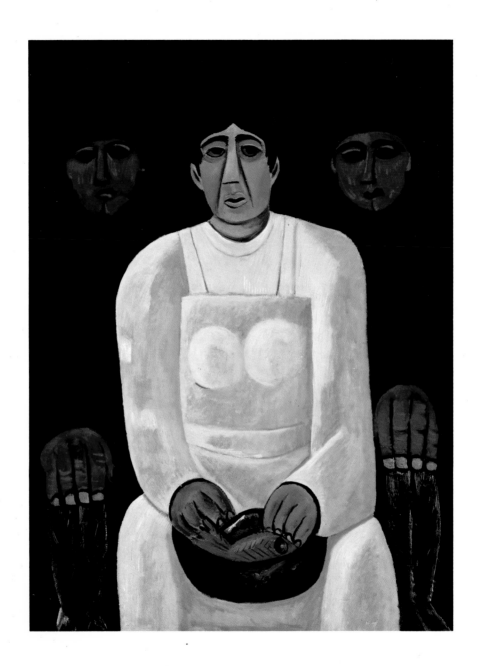

Plate 4
The Lost Felice, 1939.
Oil on canvas, 40 × 30″
Los Angeles County Museum of Art;
Mr. and Mrs. William Preston Harrison Collection.

Cleophas and His Own
The Making of a Narrative

Gail Scott

The Move to Nova Scotia: 1935

The events of Marsden Hartley's life and the way those
events have, for the most part, been interpreted in the
years since his death in 1943, present the picture of
perennial restlessness, of fortuitous encounters with
people and places (though sometimes with tragic
results), and of an agonizing vascillation between a desire
to be left alone in remote locations to pursue his art, and
a yearning for the stimulus of art centers like New York,
Paris, and Berlin. Hartley was never able, it seems to
project any kind of larger game plan for himself or his
career. His movements from one location to the next
were often a matter of a chance invitation or some
unexpected income which allowed him the opportunity
to relocate or travel to some desired spot. Such a
footloose existence was, of course, feasible for one who
had no ties to family or homestead. Yet underneath was
always the counterpoint—a deep need for stability and
roots.

Hartley's move to Nova Scotia in September 1935
was typical of this pattern. He had been through a
devastating winter and spring. As the Depression
deepened, his own financial status became increasingly
tenuous. His few supporters, including his dealer, Alfred
Stieglitz, disapproved of his recent tenure in Germany
and of his paintings of the Bavarian Alps, and he could
not sell any work. He spent a miserable winter in New
York, living on sixty cents a day and one decent meal a
week which Stieglitz bought for him. The low point
came on his fifty-eighth birthday, January 4, 1935, when
he felt forced to destroy 100 paintings and drawings in a
storage vault because he was unable to afford rent and
had nowhere else to store the works. Ill with bronchitis,
his doctor forbade him from going north to Maine or
Massachusetts that summer as had been his custom
when living in America. Somehow—partially with a $50
a month gift from an "angel"—he managed to get to

Bermuda for rest and recuperation, and after several months there was rejuvenated enough to think of traveling north.[1]

He had spent the previous summer in Gloucester, Massachusetts, where he had begun a second series of powerful paintings of a remote area of glacial rock formations called Dogtown Common. Although he enjoyed the coastal town for its picturesque fishing atmosphere, he thoroughly disliked the "summer art colony" set, and besides, Gloucester had become too expensive for him. His friend, Frank Davison, the Canadian novelist writing under the pseudonym of Pierre Coalfleet, had often mentioned to him the charm of his native Nova Scotia, and thinking it would be a cheaper alternative to Gloucester, Hartley booked passage to Nova Scotia, to meet Davison in Lunenburg. But, as his letters indicate, he missed Davison by a day and soon found Lunenburg dull, past its peak as a thriving fishing and sailing center. Taking the advice of the local taxi driver, he went up the coast four miles to Blue Rocks where he found the warm hospitality of Libby and Leander Knickle who agreed to board him for $7.00 a week. Subsequently he discovered Francis and Martha Mason, their two sons and daughter, and, persuaded *them* to board him on East Point Island.

A surface reading of these events would indicate a series of chance decisions and serendipitous encounters culminating in a miraculously suitable situation for Hartley at this particular point in his life. He desperately needed the quiet retreat and the stability, warmth and affection the Mason and Knickle families offered. In a letter written not long after his arrival at the Masons, he stated emphatically that he felt "led" to come there. Perhaps his dogged sense of integrity and his Yankee individualism conferred on him a kind of sixth sense which gave meaning and purpose to what, under ordinary circumstances, would seem bumbling confusion. This same intuitive direction had guided him many times in the past. As far back as 1908, as an unknown, untried artist he found his way to New York and to Alfred Stieglitz. Later his innate sense of place found meaning and inspiration in such diverse locations as Berlin, Aix-en-Provence, Dogtown, and Corea, Maine, in each case enabling him to discover circumstances which would lead to new work, and new ideas, despite the mitigating factors of loneliness and poverty. Confirming this intuitive sense, he wrote later to his dealer, Hudson Walker, "I have always followed 'guidance' of a sort—and notions come and become facts by proving themselves real."[2]

The Masons: Francis, Martha, Alton, Donald, Alice, and Ruby

From the moment he first met Martha Mason on the day she came to Libby Knickle's to spin wool with three women friends, Hartley's creative imagination was sparked, as evidenced in the painting *Nova Scotia Woman Churning* (pl. 18). (She became known affectionately as "Aunt Martha," an appellation common in small rural communities.) Soon after this initial encounter (around the first of November), he moved over to live with the Masons at Eastern Points, (the post office designation for East Point Island) and wrote two letters to Adelaide Kuntz—on November 4 and 6—exclaiming over his discovery of the family. Already in the second of those letters he was envisioning a portrait of the family at supper or a noon meal—a mind's eye description very close in fact, to the final painting, *Fishermen's Last Supper* (p. 14). His desire to *write* something about the family did not, however, according to letters at least, hatch until the next summer, when he returned to Eastern Points.

The Writing Begins: 1936

When he arrived in July, 1936 he came equipped with a trunk of books, writing materials, and, as he said in a letter, "a sudden new vision for writing." He kept a kind of journal that summer (something rare for him), writing not daily entries, but rather prose fragments depicting vignettes of island life. "Memory of Fragrance" (p. 76), for instance, begins with a bit of conversation with Cleophas and waxes off into a reminiscence of the orange blossom harvest he must have witnessed when living in Vence, in the south of France around 1926. His letters include long descriptions of the individual family members, already identified by the fictitious French Canadian names he intended to use when he wrote about them: Cleophas for Francis Mason and Alphonse Adelard for Alty Mason. He was still searching for the right names for Aunt Martha, Donny and Alice.[3] Thus, as with much of his writing, Hartley's actual correspondence became the germinal seed for *Cleophas and His Own,* though still as yet without its compelling *raison d'être*: the drowning of Alty and Donny Mason and their cousin, Allen. Like the original idea for a painting of the family at supper, he at first apparently intended to write merely a poetic description of the simple piety and archaic beauty of the lives of this family and their Nova

Scotia island environment.

His second summer with them progressed tranquilly and basically he was content, though as usual when he had been in a remote location for some weeks he would begin to chafe at the isolation. One letter confesses that at moments he wished to escape the "orchestral simplicity and nobility" of their home.[4] When disaster struck, however, on September 19, the idyllic peace came to an abrupt and shocking end. To Adelaide Kuntz, Stieglitz, Carl Sprinchorn, Norma Berger, Rebecca Strand, he wrote anguished letters—all very similar—recounting every detail of the drowning. The prolonged ordeal of first finding the boat, then the bodies of Alty and Allen, a funeral for those two, then finding Donny's body and burying him, deepened the wound of loss. At this point Hartley wanted to leave; it was all he could do to control his own grief, but to witness the grief of Francis and Aunt Martha was almost more than he could bear. However, Ruby, the daughter who lived in Halifax, and had, of course, come home for the funerals, convinced him to stay on as he was such a support to her aging parents.

However, by October 30, his mood was beginning to shift, and he could report to Adelaide Kuntz "a great relief" at a turn in the weather from soggy and depressing rain to a soft and gentle, almost springlike day. The weather seemed to herald a beginning of the healing of his grief. He goes on to describe how he had decided to attempt to paint in the now deserted blacksmith shop, figuring that if he could work there, amidst the tools and "general debris of labour" of the boys, he was getting beyond the grief. Describing several canvases he was finishing, he concluded, "So my reading and writing and arithmetic of this season are about done now. All in all a profitable season, save for the tragedy—and I suppose one must learn to think of it too as somehow profitable—but o, the pain and how the very marrow of the spine goes on aching with such deprivation." In his final letter to her from Nova Scotia, Hartley's thought was already turning outward, beyond Eastern Points and the Masons. Written six weeks after the drowning of the three boys this letter describes the completed manuscript of the story, *Cleophas and His Own,* claiming with satisfaction, "It is all but settled in place but needs rearrangement probably, ending of course in the tone of deep threnody for obvious reasons." The deep grief seems to have been purged in the final weeks of writing and painting, for he adds with no trace of emotion, "So with twenty odd pictures, many drawings, and two books of verse perhaps that can be called a

season of work and play This is a wondrous place for a writer though for painting not offering very much—but the life has enriched me greatly and I have lived so logically and well."[5] No mention in this final letter of the loss of the boys; emotionally he was beginning to move away from the events in Nova Scotia.

This first draft manuscript still exists, in the archives of Yale University. Written in longhand in a two-ring looseleaf notebook on lined paper, its original subtitle was "A North Atlantic Episode" with the word "Episode" crossed and replaced with "Tragedy." He had used the term "episode" before in titles of essays concerning his travels in Germany in 1933 and no doubt initially intended this piece to be a similar vignette. When the accident occurred, what had been a pleasant episode about some lovely people, was transformed into a threnody with overtones of a Greek tragedy—a comparison Hartley himself makes in the narrative.

Completing the Tale: 1941

Having finished the draft before leaving Nova Scotia, Hartley apparently did nothing much with it for five years. The few handwritten changes were probably done while he was working on the draft, such as changing the subtitle and the name "Madeleine Felice" to "Marguerite Felice." Five years after the drowning incident Hartley found himself in a locale that so reminded him of Blue Rocks and Eastern Points, that he was obviously inspired to resume work on the manuscript. In October, 1940, he wrote to Frank Davison, his Canadian friend, that he longed "to see his Blue Rocks folks again," and that he discovered a little coastal fishing village in Maine—Corea—which he loved because it so resembled Blue Rocks and Eastern Points—"such an archaic quality in the appearance of it so near the center of things & yet so removed." Having discovered this compatible place he planned (as he had in 1935 in Nova Scotia) to come back the next summer, perhaps build a studio and live cheaply and simply. He loved the Young family who took him in to board there, but added, "they do not take the place of the truly epic family in N.S."[6] He indeed returned to Corea in 1941, intending, as he told Adelaide Kuntz, "to take an imaginary sabbatical from painting," only finishing some works from before, including a larger version of the *Fishermen's Last Supper* (p. 23), but mainly devoting himself to completing the story of Cleophas.[7] Confirming the same intent to Frank Davison, he

claimed that he had "determined on a litry [literary] summer, and have dug in to heaps of high-sterical msses [manuscripts]"[8] He had finally finished typing the *Cleophas* manuscript—a task he complained bitterly about since he had never learned to type well, and the tedious work strained his eyes. The typed revision is not substantially different from the original handwritten version. He altered some wording, rearranged some of the "Postludes" sections, and made a few changes in the final poems, "Fishermen's Last Supper" and "Lie Folded Now," but none of these significantly affect the flow or content of the narrative. In effect, *Cleophas and His Own* emerged full blown in the four or five weeks immediately after the drowning incident, and remained basically intact.

He was obviously pleased with the outcome of the tale and had high hopes for its publication. He wrote to Leon Tebbetts, publisher of two recent books of his poetry, "I love more than anything else . . . the elegaical epic of those drownings," adding that he intended to show the manuscript to Kay Boyle or to Clair and Ivan Boll, on the advisory board of Gotham Book Mart.[9] Whether or not he pursued this plan is not known, but the narrative was not published. He told Adelaide Kuntz, "it is really a very sacred book to me . . . as it is a kind of farewell to certain emotional reactions."[10] Completing the manuscript—published or not—gave finality to the event. The experience, with all its anguish and sorrow, was purged in the fire of his creative effort and transformed into the gold of something larger than the events themselves, something that communicated a sacred meaning.

"A Simple and True Tale"

The idea for a story about these Canadian fisherfolk did not spring entirely from Hartley's immediate experience with the Mason family and the drowning of Alty and Donny. Hartley had in mind certain literary precedents, specifically—and appropriately enough—a Canadian work, *Maria Chapdelaine,* by Louis Hémon.[11] He had read the English translation of this tale of the hardy French Canadians of the Lake St. John region of Quebec, in 1930 during or shortly after his trip to Quebec and Montreal that summer. In his letters and essays he often included Hémon among those writers whom he most admired for their simple, direct style. The characters in *Maria Chapdelaine* were the type of people—like the Masons—

whose ethic of hard work, natural piety and courage in facing the rugged elements of their northern climate gave them what he loved to call a special "humanism." Also he probably chose the names Cleophas and Adelard from *Maria Chapdelaine* where they appear as minor characters. He told Frank Davison he wanted *Cleophas and His Own* to be "as simple and true as that [Hémon's] work . . . because it is without mental struggle, and only the spirit operates."[12]

There is undoubtedly a large measure of self-analysis in this statement. Hartley was all too painfully aware that some of his writing suffered from the weight of too much "mental struggle." In fact the volume of poetry, *Between Point and Point* which he had finished the same summer he wrote the *Cleophas* manuscript, is an example of the kind of densely abstract verse of his which is best left in the archives; it has never appeared in print and stands in marked contrast to the living, felt quality of *Cleophas and His Own.* He longed for his painting and his writing to stem from what he termed "imaginative living" and not be merely an intellectual diversion. *Cleophas and His Own,* like the best of his poetry and prose, has an authentic ring precisely because it *is* as "simple and true" as the people it portrays and, reflecting the richness of his experience with the Masons, "only the spirit operates" in it.

Other than its general similarity in subject to *Maria Chapdelaine,* the *Cleophas* narrative is stylistically idiosyncratic. As a poetic narrative, it is written with a unique prosody, which conforms to neither formal poetry nor common prose, yet the language often flows with a lyrical beauty that stems from some middle ground between the two. These are not poetic lines complete with meter, rhyme, or regulated rhythm—or even free verse in the ordinary sense, such as we would find in his other poetry of the 1930s. But at moments—such as at the end of the *Cleophas* section, "A Fine Large Morning"—the lyrical sweep of words takes us over the edge into poetry, while the final sections, after the "Postludes," are clearly intended as verse. Despite the fact that it is true to life in all details except the names of the characters, the tale is not documentary or even expository in style. It supersedes fact and strives towards epic proportions.

As a writer Hartley was certainly an anomaly. He had very little formal training, and never, in fact, graduated from high school, yet he was exceptionally well read and, by the age of forty-five, was part of the international *literati* of his day. His unconventional style in both poetry and prose is marked by passionate, evocative language

and a highly individual, freewheeling use of structure, punctuation and syntax. When he typed his own manuscripts, he would begin all sentences on a new line at the left margin without indentation, and double space between paragraphs. Because *Cleophas and His Own* lies somewhere between prose and poetry, these stylistic devices seem more natural, paragraphs acting like poetic stanzas. In the transition from the handwritten version to typescript, the end point of lines varied somewhat, indicating that Hartley did not think of the narrative in formal poetic terms with strict line endings. Nevertheless the lineation has been maintained just as it appears in the typescript in order to preserve the special flavor of Hartley's writing style. While he was in tune with the poetic currents of his day, it is difficult to pinpoint any particular model he followed. Perhaps because writing was his second vocation, he felt especially free to break all the rules and create his own prosody. This fact alone places him squarely in a modernist literary tradition.

Symbols of the Ideal

The untitled opening section is the most expository and prosaic, describing the autobiographical details which brought him to Nova Scotia and, step by step, to the Masons. Each of the next six sections portrays one member of the family in turn, each one depicted in terms of a central symbolic object which characterizes that individual—not unlike the manner in which Greek poets identify characters by a repeated metaphoric image. Cleophas, Marie Ste. Esprit and Marguerite Felice are all personified by an object with religious or mystical overtones: Cleophas—the fire of the rose which illumines him in a mystical aura as he eats the petals; Marie Ste. Esprit—a thurible ("thurifer" is the word Hartley uses) which wafts its holy incense over every domestic creature and house-hold chore of her daily rounds; Felice—the perfect symmetry of three raisins placed on each cookie she bakes as symbol of her God-ordained duty to Him and to her aging parents. Adelard's symbol is the volcanic flame, while Etienne's (the name he finally chose for Donald) is a smoldering, gentle smoke.

The use of mystical symbols and the general religious overtones of the work are not new in Hartley's writing or thought. Ever since his young manhood, Hartley had been delving into the subject of religion and mysticism.

His early letters to his friend Richard Tweedy, at a time when he was seriously contemplating entering the ministry, sound like fervent sermons. In his pre-World War I period, he was interested in the work of Stefan George. He was one of the first of his contemporaries to read Kandinsky's *Concerning the Spiritual in Art,* and became friends of and showed with other Blaue Reiter artists, including Franz Marc, Paul Klee and Gabriele Münter. His favorite American painter was Albert Pinkham Ryder, whose work was enigmatic, often with mystical overtones. He loved the poetry of Blake, Francis Thompson, and Yeats. More recently, while in Mexico (1932-33) and subsequently in Germany, in the Bavarian Alps (1933-34), he had been reading Plotinus and the lives and works of various Christian mystics, including Paracelsus, Jacob Boehme, Richard Rolle and Jan van Ruysbroeck.

However, until he met the Masons he had thought it impossible for a visionary to live successfully in the modern world with its mechanistic life-style and ❧ materialistic pursuits. Francis Mason, as a "natural mystic," reaffirmed for Hartley the possibility of living the ideal in the midst of the objective real. The choice of the name Cleophas for Francis Mason is particularly appropriate: besides the association with *Maria Chapdelaine,* it has a Biblical derivation, both as a relative of the Virgin Mary and as one of the disciples to whom Jesus revealed his true mission on the walk to Emmaus after the resurrection.

Moreover, in the narrative, Cleophas becomes the vehicle through which Hartley recounts, in a kind of interior monologue, a mystical experience of his own, which he had had while in the Alps two years before. As he recounted in a letter to Stieglitz, it was during a walk at Garmisch-Partenkirchen one afternoon that he saw "the keystone drop into its place—not only seeing it but actually feeling it." The "vision" recurred a second time— thus confirming his intuition as to its significance. He likened the experience to what St. Augustine's followers called the "Mystery of Opening":

> The whole vision of life was opened and I knew the work of my life had been completed. I was being pursued not [so] much like Francis Thompson by a hound of heaven, but by a kind of courier of the realities who had a message for me and caught up in Time. I thanked the courier & he went speeding on his horse again . . .
> There *is* something that protects us, or

how could [a] simple one like me have
proce[e]ded. I can't give it a personal name
for I have never seen a person, but I
certainly can think of it as the element of
good in my life, and I must believe in it
from now on . . . and so you see one can go
to church anywhere & pray standing up at
all times because simple, true desire is
profound prayer.[13]

The letter confesses this experience to a close friend.
When he decides to relate it publicly in the context of the
poem, he chooses, significantly, Cleophas with his
sympathetic consciousness as his confidant.

Cleophas, Marie Ste. Esprit and Felice personified for
Hartley a religious ideal because they were able to live
out a spiritual reality in their everyday lives and were
animated by a "practical mysticism." Cleophas, Hartley
tells us, is "a natural mystic of the sea" who "is ardent in
his belief that law is life and life is love." Hartley had
been raised in the Episcopal Church, loved its ritual and
forms, but was not religious in the doctrinal sense, and
did not regularly attend services. But Cleophas and his
family were, in his view, what religion is and ought to be
all about. The narrative relates how he enjoyed going to
church with the family—Cleophas all dressed in his
formal black suit with gold watch and chain, singing—
slightly off-key but so earnestly. On these occasions,
especially, Cleophas's face was illuminated with "literally
the glow of heaven." Then the narrative introduces
Cleophas's ecclesiastical counterpart, the local Episcopal
minister, in a comparison which epitomizes, with
sardonic Yankee humor, the difference between
authentic piety and superficial religiosity. The young
minister "is an anemic theopath," with wooden body,
eyes like fishscales and when closed like the eyes of the
dead. "He is given to gentle but flatulent exhortation, he
might be addressing a herd of seals who do no better or
no worse than destroy the nets." The minister's
ineffectuality was the cause, according to Hartley's
letters that summer, of much local gossip, culminating in
a Halloween prank of knocking over his outhouse.

Portraits in Verse and Image

The four sections of the tale, "Fine Large Morning," (Cleophas), "Marie Ste. Esprit," "Marguerite Felice," and "Alphonse Adelard," are verbal equivalents to the four painted portraits, *Cleophas, Master of the Gilda Gray* (pl. 6), *Marie Ste. Esprit* (pl. 3), *The Lost Felice* (pl. 4), and *Adelard the Drowned, Master of the Phantom* (pl. 2) which he had conceived while in Nova Scotia, but actually executed in 1938 and 1939. Unless one is familiar with *Cleophas and His Own*, the mystical implication of their lives (except, perhaps, for the connotations of Cleophas's and Marie Ste. Esprit's names) is not immediately apparent. Here the written word and painted image complement and enhance each other, as they rarely do with an artist, bringing new meaning to the surface.

Together the painted and verbal portraits are a distillation of all the family meant to him. As a unit the Masons offered Hartley the brief opportunity to experience genuine, family affection in a way he had never had as a child. He was the ninth child and only boy; his mother died when he was eight, and his father, unable to care for the boy, left him with an older sister for seven years. His childhood and youth were not especially happy, and throughout his adult years he never had a home he could call his own. Thus the Mason family, bound together by mutual respect—even reverence—made a deep impression on the solitary Hartley. He was moved by Felice's beauty which he defined in terms of her duty and love for her elderly parents; he saw the parents' forgiving, unconditional love for the boys despite their periodic drinking binges; and the boys' own contrite attitude and deferential respect for their parents. This was the kind of familial affection for which he had always yearned. He told Adelaide Kuntz, "I do have such a sense of relatedness here, true relatedness as perhaps never experienced before save in earlier Germany perhaps"[14]—referring to the year 1913 when he stayed for several weeks in the family home of his German friend, Arnold Rönnebeck. Besides the Masons, this was the only time he had experienced what it meant to have a real family.

He had always valued highly his relationships with people and considered himself a loyal friend. He felt he had a "deeply brotherly" relationship to Cleophas with whom he could share his most profound thoughts despite the vast differences in their respective backgrounds. For both Alty and Donny he felt a paternal and fraternal affection, with homoerotic overtones. His letters and the narrative itself relate moments of

unselfconscious physical encounters between the men,
such as Alty's bear hug when they first met, or when
Hartley washed Alty's back ("like scrubbing an acre of
granite"), and embraces between them and the other
youths who flocked around gregarious Alty. In his
letters Hartley describes this as exciting but typically
"platonic" behavior among these men who went to sea
for weeks at a time with only each other for company.
What is ultimately most important about these
relationships is that he found a longsought acceptance,
affection and the inspiration to work.

The Drowning: September 19, 1936

After the six portrait sections the text continues with a
passage titled "Evening by the Seawash," setting the
idyllic scene in which these island people labor.
Describing the men returning from the day's work of
haying, the evening chores of milking and bedding down
the oxen, cows and calves, Hartley quotes Flaubert, "Pas
une atome de nature que ne contie[n]ne pas—La Poésie"
(Not an atom of nature which does not contain—Poetry).
Further, he portrays the women waving goodbye to the
departing fishing boats, wondering if their men will
return safely. This interlude stands in dramatic
counterpoint to the events which follow. The next
section, "Constantly October," is a prefiguration of
coming events and describes the funeral of an "uncle" in
Blue Rocks. The tension then builds ominously toward
the tragedy which is the focus of the tale.

The passages recounting the hurricane and its tragic
aftermath of death and loss are told in straightforward
prose interspersed with phrases and images of
memorable import: "the evening-faced mother" grieving;
Felice hanging out the boys' clothes on the line, "the
manly shapes of Adelard and Etienne swinging ghostlike
in the sun . . . every article displaying a certain
determination to retain its identity and moods of two
strong things in life, acres of strength, acres of
gentleness, acres of soft good heart, acres of
childlikeness, two men whose images were hung out
on the line for a little sunlight"; and of saying goodbye
to the "great Cleophas [who] straightened his
shoulder, hitched up his trousers . . . stood like a
monument
of beauty and anguish as well as power and
simplicity, humbly twisting a piece of rope between his
thick fingers."

A Threnody

As a threnody *Cleophas and His Own* represents a culmination of Hartley's mature elegiac works. Death had been a dominant factor throughout his life, and permeates his writing and painting, especially in the later years. In 1914 his close friend Karl von Freyburg had gone off to World War I in all the pomp and glory of Prussian tradition (much of which Hartley witnessed in Berlin that same year)—only to be killed in one of the first major battles of the war. His series of memorial, symbolic portraits executed during that year and the next have been hailed as some of his best and most original paintings. Then in 1933 he wrote a long poem and several essays and painted a memorial, *Eight Bells' Folly* (p. 24) after his friend Hart Crane committed suicide by jumping overboard on a return voyage from Mexico to New York. In addition he wrote, over a period of several years, a series of essays called "Letters to the Dead" or "Letters Never Sent" which are tributes to dead friends, or writers, artists, and musicians whom he admired. The theme of death pervades his poetry as well; there are poems addressed to dead birds and animals, to soldiers lost in war, and poems about the passing of summer and dying autumn. Perhaps because death had played such a part in his life, Hartley was at his best when writing about it and seems at home with the elegy. Yet the experience in Nova Scotia and his grappling with the tragic episode did not harden his attitude into cynicism as tragedy sometimes does. Rather, as the narrative itself demonstrates, Hartley was left simply with an afterglow of richness and strength. He told his niece, "I have no fear now as to adversity or death—I am rich in what I have—freedom for mind and spirit and that is a great deal."15

The main part of the *Cleophas* manuscript ends with a poem which corresponds to the painting, *Fishermen's Last Supper*. What began soon after meeting the Masons in 1935, as an idea for a straightforward group portrait, evolved after the drowning into something quite different, taking on a religious connotation in its title and solemnity of mood. The first line of the poem confirms the liturgical inference, "For wine, they drank the ocean, /for bread,/they ate their own despairs."

This poem and the five that follow in the "Postludes" section mourn the loss of the boys by focussing on three aspects of their deaths: the dispassionate cruelty of the sea in particular and nature in general; Alty's brash foolhardiness which led to the tragedy; and the fact that those who are left behind suffer more than those who

died. In "Fisherman's Last Supper" the moon is a benign
natural agent giving "counsel" which, because of Alty's
"foolish contention" went unheeded. The sea, on the
other hand, is portrayed as malicious and blindly cruel,
without "remorse, or pity" and a deceiving murderer
who makes itself "pretty" but has no regard for either
"the foolish" or "the brave". Probably the most radical
textual change Hartley made in the *Cleophas* manuscript
was to cut the last three stanzas of "Fisherman's Last
Supper" and to revise the second stanza significantly.
The published version which appeared in 1940 in
Androscoggin, along with "Two Drowned at the Gateway"
and "Two Lovely Ones"[16]—both of which relate to the
Nova Scotia episode—reads simply:

> For wine, they drank the ocean—
> for bread, they ate their own despairs;
> counsel from the moon was theirs
> for the foolish contention.
>
> Murder is not a pretty thing
> yet seas do raucous everything
> to make it pretty—
> for the foolish or the brave,
> a way seas have.

✘ The lines "yet seas do raucous everything" and "a
way seas have" have been revised and do, in fact, along
with the deletions, make a more taut and poignant poem.

Postludes

The "Postludes" contain a mixture of poems and short
prose pieces. The three prose passages tell of life going
on again, despite the fate of the boys, yet changed by it.
The men take to drinking again "to cover certain losses."
It was as if "You could hear Adelard bellowing aloud
again with his velvet basso voice, talking loudly of speed
and action," while the "dulcet whispers of lyric calm" of
Etienne's voice can also be heard. "It is Like" tells us "Life
is different" but at the same time perhaps the boys "have
only gone away duck-hunting up among the small
islands toward the north." "Taking the Oxen to Good
Grass" conjures up a memorable picture of the island
method of re-pasturing the oxen by transporting them in
two dories tied together. It also projects (reminiscing
back before the accident), a powerfully evocative image
of Etienne, strong as an ox himself, carrying the less
surefooted Hartley piggy-back from boat to rocks.

The five poems in the "Postludes" section continue
the elegaic theme, focussing on the pain of those who
remain, "O boys—you have nothing now/to meet/what
we have to meet." "Voice of the Island" is a *missa solemnis*
for the boys' deaths, comparing their loss to the many
migrating birds who "perish on the way" as "savage
winds beat them into the sea." The voice of the island is
the voice of the mourning "seastricken" mother who
bemoans the injustice of having three of her youths
taken. The voice of the sea "whimpers" back "can't do
anything/with them, now I have them—/you take them
earth." Like the ringing of the bellbuoy, the poem
laments, "Too soon, too soon, too soon" the youths were
taken and "too much, too much, too much" pain for
those left behind. "Adelard the fearless,/Adelard the
brave" dared recklessly for love to defy the "fleawhisper"
hurricane.

"They keep returning" is a dirge for those who
remain: they might be able to "stand" again "to face run
of days and whirl/of sea" if only the grasses would not
blow and leave "visages" and "smiles" of remembered
ones; if only the grasses wouldn't whisper their "stark"
message of coming winter; if only the "minor/wouldn't
press on diapason key/so"; if only the smiles out of the
grasses wouldn't beckon us that remain to

> come hither, let us wrap you round
> on the old, tried, common ground—
> let us make worn, torn places smoother
> with our tendril traces
> heal broken places
> of steel murmur in severed places.

"Fishermen at bread and wine" evokes an image of
Cleophas and his brother kneeling in the island
schoolhouse partaking of the communion wine and
bread. On Sundays they participate in the church ritual,
but, as we noted earlier, the poet sees their everyday
work and play as living witness to the sacred
"remembrance". Unlike the three dead youths, Cleophas
and his brother in their maturity and greater wisdom,
respect nature and the sea. They know that the
"wickeder the sea, holier it gets/ something is there,
something is there—/it is the POWER . . . that brings
these noblest two [to] prayer."

In the final poem, "Fishermen," the raging sea, like a
ferocious Poseidon, cries out, "I'll have them both" to
"bring a wealth of warming" to those poor souls trapped
already in his dungeon at the bottom. This image of
those lost at sea remaining incarcerated in Davy Jones'
Locker recurs from earlier Hartley poems. In the "Ironies

out of St. George's"—songs of lament for soldiers lost in World War I, (written in 1918 when he stayed at St. George's, Bermuda)—the sea is personified in much the same way, as a detached, unscrupulous captor of brave young men who stare up out of the water keep. Later *Eight Bells' Folly* (1933), the memorial painting to Hart Crane, the eyes of the drowned emerge out of the water, searching for solace and company. In using some of these images Hartley might have been influenced by another poet of the sea, John Cabbage whom Hartley had known in that same period, and whose two volumes of poems, *8 Bells* (1932) and *Time and Tide* (1938)—both of which he owned,—treat many of the same images of the cruel sea and drowning men.

The Poet's Voice

Besides the verses at the end of the *Cleophas* manuscript, there are numerous published and unpublished poems, written after 1936, which might well have been inspired by the Nova Scotia experience. Most notable among these are "Encompassed," "Three Loving Men," "Two Drowned at the Gateway," "O Bitter Madrigal," and "Casual Frontier." "Encompassed" seems to evoke the image of Alty who "Encompassed me in arms/concentric" and whose "eyes burned like flames in burning/tree" and "Hair stood on end like fury-fire/mouth blowing steam of thick desire." It is a love poem—revealing Hartley's yearning to love and be loved. "Three Loving Men" speaks directly of Adelard and Etienne (Hartley being the third man) who are "consummate men/each loving each." The poem tells of their plans to build a house for him—until, that is, "Black went the sky/pale went the house . . . death dancing after/house fell to ruin/for three men." In the third of these poems, "Two Drowned at the Gateway" Hartley again refers to the imagery of drowned ghosts walking the sea at night and sleeping in its depths during the day. The Gateway refers to the narrow channel, or gut, as it is known locally, leading to their own island from Blue Rocks, where their bodies were found. The mother looks out of her window each night, sees the lantern glowing from the brow of one son's ghost, and hears "nothing but the moan of the wave/and the windgroan." "O Bitter Madrigal" relates to a drawing Hartley did with the same title (pl. 18), depicting a pietà-like scene of a kneeling woman holding her dead son in her lap. On her shoulder a bird whispers the "bitter madrigal."

"Casual Frontier" contains no specific reference to the Mason family but concerns the sea and drowning. The poem, like the others, is pervaded by the feeling of helplessness, the fragile ("casual") line between life and death, especially against the natural elements of sea and wind. However, in spite of this fear of death, which encompasses the human condition, Hartley was no nihilist. Beneath the bitter tone of sorrow and pity, in "Casual Frontier" and the other elegaic poems of this period, there can be heard a small voice proclaiming man's immortality. His portraits of the Masons, his poems to dead creatures, his "letters" to dead writers and friends, are affirmations that life continues, that these people and creatures did not live in vain but are remembered—in part because of his own creative record of what they were and therefore are. In "Casual Frontier," the speaker is the drowned one whose voice— "the last all but lost note in my throat"—is nearly obliterated by the "brute shout" of the wave. But "the power of the word" will utter a cry of thanks and a "choked whisper" will be a clarion call to stave off oblivion. The "voice" is that of the poet who can wield the "power of the word" and thus give empirical proof that death and oblivion do not, in fact, have the final say. This poem, though not directly linked to the events in Nova Scotia, represents perhaps the quintessence of that experience, both for Hartley and for us, his audience. The struggle to deal personally and creatively with the accident and the deaths of Donny and Alty was the poet/ artist's effort to save himself from the despair and loss that threatened, like the "brute shout" of the sea swell, to "take him in at the scattering" and "to drown out the last all but lost note in [his] throat." But in the end the poet's voice prevailed; his "choked whisper shall have empirically then/been made clarion." The goodness and spirituality he witnessed daily in the Mason family gave him the strength to fling up a flag (the paintings, poems and *Cleophas and His Own*) "to stave nonsense of the grave," to declare with clarion triumph their immortality.

Hartley's encounter with the Masons was relatively brief, but it had potent and far reaching effect on both his art and his life. By his own admission his character was changed by his association with the family; he liked himself better and felt restored to a finer degree of humanness.[17] From early manhood Hartley had immersed himself in mystical literature and thought, but not until knowing Francis Mason and his family did he discover what it means actually to live a life of grace. In *Cleophas and His Own* he was able, for the first time, to

articulate in poetic form what he had been reading and thinking about all his life. The 1914-15 German officer paintings, which were Hartley's memorial tribute to Karl von Freyburg, are stunning paintings, marking the successful advent of his career and his original approach to European modernism. The Nova Scotia experience, with its exhilaration and its tragedy, brought forth a wonderfully cohesive body of work, in both painting and verse, executed with a degree of mastery and depth of meaning that could only come from the creative imagination of one who had wrestled with the difficult and painful issues of death and immortality and emerged from the fray strengthened and clarified.

Notes

1. Hartley's letter to Rebecca Strand, July 29, 1935 recounts these events, Archives of American Art (hereafter cited as AAA).

2. Letter to Hudson Walker, n.d. (probably February 1941), AAA.

3. Letter to Adelaide Kuntz, Sept. 9, 1936, AAA.

4. Letter to Adelaide Kuntz, Sept. 6, 1936, AAA.

5. Letter to Adelaide Kuntz, Nov. 9, 1936, AAA.

6. Letter to Frank Davison, Oct. 17, 1940, Yale Collection of American Literature (hereafter cited as YCAL).

7. Letter to Adelaide Kuntz, Sept. 29, 1941, AAA.

8. Letter to Frank Davison, Sept. 17, 1941, YCAL.

9. Letter to Leon Tebbetts, n.d., from Corea, Maine, YCAL.

10. Letter to Adelaide Kuntz, Sept. 29, 1941, AAA.

11. Louis Hémon, *Maria Chapdelaine: A Tale of the Lake St. John Country*, tr. W.H. Blake (New York: Macmillan Co., 1921; first published serially in Paris, 1913).

12. Letter to Frank Davison, Sept. 17, 1941, YCAL.

13. Letter to Alfred Stieglitz, Nov. 21, 1934, YCAL.

14. Letter to Adelaide Kuntz, Oct. 30, 1936, AAA

15. Letter to Norma Berger, Oct. 6, 1936, YCAL.

16. *Androscoggin*, (Portland, Maine: Falmouth Publishing House, 1940) pp. 15-16, 25.

17. Letter to Adelaide Kuntz, Nov. 6, 1935, AAA.

The Making of a Narrative

Note

The text source used for this published version of *Cleophas and His Own*
is a compilation of several manuscripts. Basically there are two distinct
typescripts: a complete, 40 page version, divided into the main
narrative and a "Postludes" section; and a 15 page, apparently
unfinished typescript. It is unclear when the latter typescript was made
or why it was abandoned, but for purposes of the text printed here, we
will be referring only to the finished version. The first draft, a
handwritten manuscript, the original typescript and two carbon copies
are in the Hartley Archive of the Beinecke Rare Book and Manuscript
Library of Yale University, with whose kind permission we publish
Cleophas and His Own, the related poems, journal entries, and selections
from Hartley's letters to Adelaide Kuntz. Bates College in Lewiston,
Maine, owns another carbon copy. Each of these carbons has different
corrections in Hartley's hand, but all the differences are essentially
minor word substitutions, corrections, or different arrangements of
the "Postludes." He made no major alterations to the narrative itself.
The present version incorporates most of the handwritten corrections
and emendations from the original typed and three carbon copies.

As mentioned in the text, even though *Cleophas* is not written in strictly
poetic lines, Hartley's lineation has been followed. The only editorial
changes made to the text are the addition of occasional quotation
marks; the elongation of his single dash to the traditional double (em)
dash; capitalizing the adjectival form of certain types of proper nouns
which he usually (but not always) put in lower case (germanic, english,
etc.); and substituting a period for his semi-colon at the end of some
paragraphs.

G.S.

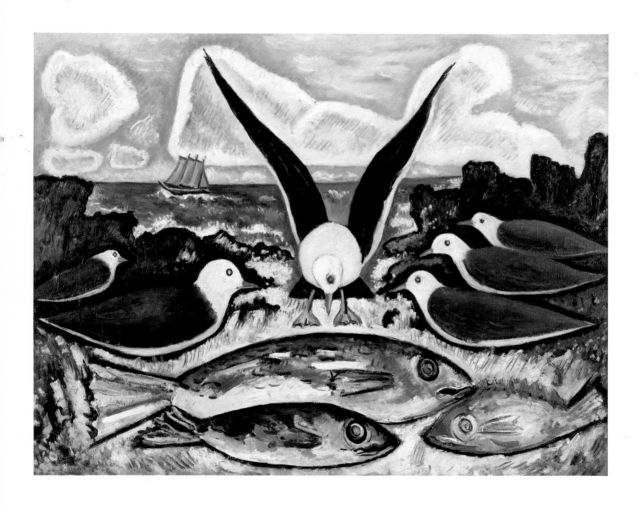

Plate 5
Give Us This Day, 1938-39.
Oil on canvas, 30 × 40"
Shaklee Corporation,
San Francisco.

Marsden Hartley's Journal Entries, Nova Scotia, 1936

Memories

I have but barely settled down on these Nova Scotia
shores for the summer, the 'Hindenberg' had flown over
the [horizon] at seven this morning. I have not yet got
out of the whirl of the city into the marches of the
lonesome sea which have great distinction when one
really gets into them and out of human notions that
human beings are all of life. I brought a small trunk full
of books because one can't be mentally idle for months
without returning to the world through the medium of
words. I saw in front of me *Murder in the Cathedral*,
Thomas Mann's *Stories of Three Decades*, Mauriac's *Desert of
Love*, Hopkins' *Poems*, Auden's *Studies*, Fanny Fern Felicia
Hermans who is still good for the parlor table if there is
still a parlor, and then I noticed two books of Elizabeth de
Graumont, ex-Duchesse de Tournant the one which I
bought for twenty-five cents with the title *Pomp and
Circumstance*, the other called *Years of Plenty* for thirty-five
cents both in excellent condition, and never was there a
more delectable bargain to be had, for if there is a more
cultivatedly entertaining writer I do not know of him or
her and as the seagulls swirl around me and seem to take
on the hues of white from the tossing spray ahead, I
read, and avidly, *Years of Plenty*.

I am speaking of course of the English translations,
and in *Years of Plenty* this author makes the statement in
the chapter called Mornings in Africa—"Memories are
the only steadfast fixtures of our being" . . .

Memory of Fragrance

Cleophas is the fisherman's name; he is seventy and like
a great actor who has set aside his roles. His diction is
flawless and might have set a Booth to praising. We were
speaking of hummingbirds, and of their amazing flight to
Mexico each season's end, from no matter what north—
I remarking of the recent skilfull photography of the
hummingbird's wing movement—sixty beats to the
second.

We talked of honey, the pronunciation of the word
lichen as he noticed I had used the lich form instead of
the other or 'liken' use—all this because I had been
describing the incredible workmanship in the nest of the
hummingbird, and then we turned to the pot of honey
on the table and it came to me then to tell him of all the
kinds of honey in the Alpine country each with its own
Alpine flavor. You may find these in the [freight?] shops
just as you find so many cheeses in some.

"What does it smell like" said Cleophas pointing to
the honey-pot in front of us.

"O Cleophas," I said, "it smells like all the flowers
rolled into one," and the conversation placed itself on
other things.

With a kind of sharp poignancy which is the essence
of some degrees of memory, my mind dwelt upon the
word fragrance, and as I was lying in bed, from the union
of the words fragrance & memory I was suddenly
perched up on a high cliff on the valley of the Var in the
medieval town of Gattières—this in the Alpes Maritimes
of course.

It was harvest time & the harvest was the most
precious I have ever encountered for the harvest was of
orange flowers.

On every slope in these regions you see tailor-made
orchards, terraces really of button like orange trees, set
in rows as on a faded military uniform of past wars, and
the fruit is not of the edible sort—it is converted if
allowed to develop, for use in the making of liquers, but
the real harvest is of the flowers.

It is evening there in the harvest time of orange
flowers, and as you walk along the high road above the
river bed of the Var quite dry but for a trickle at the side,
and in the distance the snowcapped peaks of the
mountains of Italy.

You have had your supper and you must have a walk before night comes down.

In harvest time a heavy fragrance overtakes you and gives you the imagined sense that it doesn't matter where you are, and you may call it if you like the Vale of Cashmere or the groves behind the Taj Mahal.

Wagons come into view at the turn of the road and they are piled high with sacks and the peasants are piled upon them.

The sun is down, the snow peaks have gone into an ultra violet condition, the river bed is in the bluest of shadow—the little ancient hill towns perched on rocks seem to melt back into their original rock state—all the world is enveloped in fragrance and the end of evening.

You follow the wagons of course into the central plaza of the town where the cooperative takes charge— bags weighed in, credit slips given & the ghostly streams of fragrant white from out of the bags upon the plaza floor.

The moon is up over the hills now and it begins to make traceries everywhere. The balconies above the plaza begin to be peopled with dark figures, and the staircases that lead down to it are studded with hypnotized figures.

No one says anything above a whisper, everyone is looking down without a word at the singular white carpet below, a foot thick surely of orange flowers & from them an almost stifling fragrance arises. You think of nothing that does not partake of dream-nature— worlds forgot & the ways of men . . .

The moon is high and the blanket of flowers consequently whiter and still more ghost-like in its appearance; no one seems to want to do anything—the leaners out of windows and the standers on the staircase—lean over the respective balustrades in a state of hypnosis. The snow peaks have gone to bed for the night, a cloud clings here & there as if to have its sleep as well. The night grows older—older people meander to their beds and new young lovers cling to each other as if the scene were the unimagined epitome of their plain emotions . . .

It was Cleophas of the north that set me on the trail of this memory of fragrance, asking as he did what the pot of northern honey smelled like. "Like all the flowers of the world" could be the only answer.

Our Island

This is the only island I ever knew. There are countless like it doubtless, but was ever an island of its size wilder, more terrific, more untamed and untamable than this one.

There are people living on our side of it, the inner side, the shore side. They intertwine, raise families & go to their death on the inner side, from which years of fishing has accomplished all they know of success.

There is no hunger—no one is idle—no one will ever need assistance & fail of receiving it—the pulse of the community is full and responsive—no one is surprised— they know each other for generations—no one deceives.

You follow the curves and breaks of the shore & you find histories of centuries at your feet—the bull follows the cows & between his feet you see the sea dashing and the other island out at sea where two families live—the lightkeeper and his son and a woman a mile away lives with her deaf-mute husband otherwise they have only seagulls & petrels for neighbors.

When I go to the outside on the shore to bathe & lie in the sun, I can tan all of me because there is never a one who passes and my only associates are the waves, the rolling pebbles, & three blue herons who rise & go to the center of the island at my approach, or if one stays, I

never know which of the three it is, for they are alike in all their looks & ways.

If you keep perfectly still you will see one take a step or two regarding every horizon & he will fish out something or other from the waters & make away with it.

You walk through the all but impassable shrubbery on the inside & you come on urchins, clam shells & mussels in the deepest of the woods, crows & seagulls have carried them there, and crows have learned to fish here—you will find them down at the water's edge, as you will find seagulls perched upon the tops of the spruces—as many as six in a row like ornaments on Christmas trees to be placed around a nativity creche.

There are fresh water ponds & sloughs in the center of the island & they come almost down to the sea, and on the edge of these you will find kingfishers flying up to safety as you pass.

It is said that in the autumn wild deer have been known to swim over from the land, feed awhile & then return & last year further down the shore, a deer was found that had fallen over the cliff & broke its neck among the boulders. There are no highways on the island & where the people live on the inner side, only a thin path made day in day out by the few feet that walk over the spine-like rocks more like the vertebrae of prehistoric animals than anything else.

The One to the Sea

He might be twenty-two now—he might be more—he was a giant in stature and the soft look of not knowing what to do next until life overtook him & showed him how, or how not, and which ever it would be, he would have to think a little. In his oilskins which are really rubber clothes now, that is short overalls that covered the rubber boots with their red labels on them saying this brand is the best—he did more watching than doing, for youth is often like that, for it hates to do what the generations have done before it, thinking it common to fish, for example, as if there could be no enthusiasm for a full net even with youth, and so it stands and looks as if it were dreaming and the older men have to ask for this or that tool of labour, as the thick coils of bronze hair play back & forth in the wind, and the fish scales already clinging to his over-alls fluttered or shivered rather, in the breeze, as a summer moth lies dying after having been nipped by a spider, would shiver as if to get back a little more life on the body of the herring it had left before it too gave up its herring-ghost.

When the thick warm lips decided to part, to respond to more sudden breathing, thick lips that gave [pure?] form to the coin-like profile, their hard white teeth would be disclosed and as the children of other men clustered around his feet to learn fishing with a small hook & line, he would show them how but his big thick, hard hands would give the right twist to the line and a small fish would come up, whereas the little hands that tugged would always lose the fish because power had not come to them or cunning, and the parting of the thick lips showing hard white teeth would become a smile and the children seemed to know this smile and were comfortable with it and their little eyes would look up & they would say, see Allan, there's another one.

It could be guessed that a certain apathy toward small fishing was brought about because he had been up to the "Banks" and done all the hard stuff as there the sea had so much strength it makes men work for their footing as well as their wages & to live through all that strength of sea, one must be strong and trustful—one must always hold fast to the thought that the trip would be over some time & thus one could go home and like the sound of crunching earth and scallop shells on land where there is a white fence a garden behind that and a white or a red, or a yellow house behind that, and inside of that there would be something like peace and goodwill.

Even though these giants know of stories and sinking ships and sailors washed ashore in each other's arms, the last thrust of death, none of them liked to think it could or would be them, even though it had happened to their grandfathers or their fathers, their uncles or their cousins, or even their brothers, for everyone likes to think himself immune from travesty, even on the sea, for at no time is strength and power and faith so impregnable as at this age, or so haughty and ashamed to do things its elders have done.

Yet he couldn't help but think of the twos that floated on the sea when the waves had torn them from the ship & then tossed them together.

We can do even this together they seemed to say as he saw them in his mind's eye—we have clung to the same knees at the same epoch—we have wrestled together—we have laughed and been surprised together. It will be more in keeping if we do this together for when we cannot speak anymore from the waves in our lungs, they will see that at least we could do this together—and they often find them like that in the north—fastened tightly together in each other's arms and possibly [even] have to bury them together so informed is this embrace.

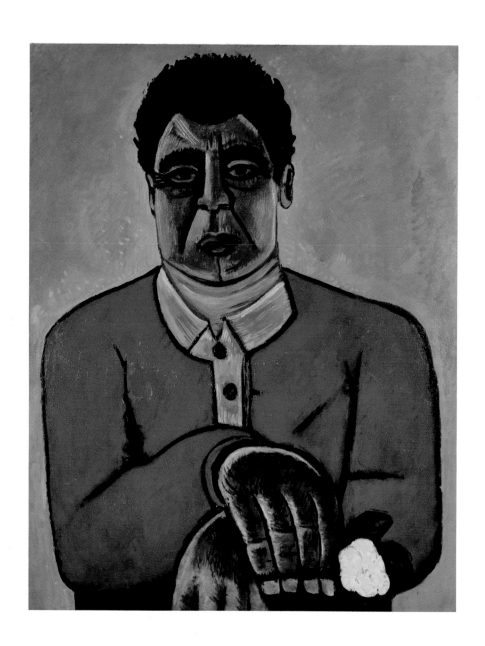

Plate 6
Cleophas, Master of the Gilda Gray, 1938-39.
Oil on board, 28 × 22″
Walker Art Center, Minneapolis;
Gift of Bertha H. Walker,
T.B. Walker Foundation.

CLEOPHAS AND HIS OWN
A North Atlantic Tragedy

Marsden Hartley

The title and dedication pages are reproduced from Hartley's typescript.

CLEOPHAS AND HIS OWN.

A North Atlantic Tragedy.

by

MARSDEN HARTLEY.

"Si tu n'avez pas connu"/

"If I hadn't known you,how I should love
to have known you".

Lines of an old French sailor song
sung by the late and very gifted
YVONNE GEORGE.

Cleophas and His Own

For many years now I have enjoyed the close friendship of a Canadian novelist—
he came to me with a letter from an American woman friend then residing in
London.
I think you will like this man she said.
There was at once something about him, a genuine magnetism born of deep
sensitivity, true cultivation, and as has since been proven, a great gift for
friendship. We had and have in the seventeen years I have known him, talked
frequently of Canada and his part of it, he coming from a solid family of ship
builders and sea people.
I must go there one day I said, having had a sense of Canada all my life, being
born in Maine.
After many years out in the world, twice around it, a sense of longing came over
him and as occasion offered, he decided to go and visit his home haunts.
His descriptions were of course lyrical, as who is not lyrical after many years
absence from the place he is born in, and for which he has a natural sense of love.

I was then living in Bermuda for the second time in my life, and took a little house
on the north shore directly under the Governor's Palace, and from the rear fence
one could look out over the nacreous waters of the coral reefs, out to infinity.
The owner of the house was the young and handsome son of a large family, and
as the mother was of diluted Italian origin, this son took on the dark florid
complexion of the maternal side of the house.
There was a large family of sons and daughters, all the rest of whom were
inclined to blondness without doubt from the father's side since he was of English
origin, excepting this one son, who got all of the best looks of the entire family.
He was a plumber by trade, and as he had sent his wife, an American woman with
the children up to the "States" for the summer, he was alone in the house, and so
rented all but one room to me.
We grew to be genuine friends and his home-coming in late afternoon took on a
kind of domesticity almost, for men with families often like to be alone with men,
for a change.
I used to go fishing with him Thursday afternoons and Sundays, the two summer
holidays in Bermuda, when all the merchants and gentry have yachts of their
own and go picknicking up and down the near coral waters.
This jolly tar liked fishing and did this with traps instead of with lines which he
did not like, the traps being something like our own lobster traps save they were
made of chicken wire mostly with a simple wooden frame.
Twice a week he would go out and haul these traps six miles out over the reefs,

and as he never made a mistake, he seemed to know always by the lay of the water or the colour of it just where he had cast these traps, and would haul up tropical splendours of an incredible variety, chiefly parrot fish, sapphire blue angel fish with lemon yellow fins and tails, and an occasional rock fish, something like our cod, and the only edible one of the lot.

The summer was unique, though excessively hot.

I got word from my Canadian friend that he had returned to his native land, and that he was in the certain town he named, doing his writing.

As I had to vacate the Bermuda house early in September, I did not want to go back to New York at that time of the year, so I went up to Boston, and took the boat for Yarmouth, Nova Scotia, arriving there early in the morning, taking a train for the given destination, and let's call it simply, Deep Waters.

Arriving at Deep Waters in the late afternoon after a long day's train ride, a taxi man of strong build, pink complexion and smiling face, very Germanic in appearance—collected my things and took me to the prescribed house where my friend had been staying, only to find that he had returned to the large city, so I was obliged to settle in on my own.

I didn't like Deep Waters, once a tremendously stirring fishing center, when there were never less than seventy-five fishing vessels in port at one time, now never more than fifteen.

I did not like the house in which I was staying, and when the taxi fellow saw my paint box, he said O you must come out where we live, it is nice out there—how far is it I asked—four miles up shore he replied—I will walk out on Sunday I replied, the which I did and found another world, an archaic world, a friendly world. Most of the houses were painted a strange hot yellow, some were a dark burning red, and a few were white with white palings in front of them, all perched upon the rocks like so many bird cages out of which Nordic birds might come, which in the end proved to be true, for the people were strong, vigorous, energetic and gentle, showing in every look and movement that they were used to the terrors and the horrors of the sea.

They also had that contented look of deep-sea fishermen at home on land, loving to do plain land labours in the arms of safety.

After a short visit with the taxi-fellow and his folks, I had decided by then that I should like it there, that there was something in this place for me, a kind of oblique severity and beauty emanated from its behaviours and appearances, the disclosures of which were to prove the richest and noblest experiences of my life, as later will be shown.

The people next door sometimes take people in said the taxi-fellow and so we went over to call on them, who were afterward to prove so utterly endearing to my memory.

The house was the oldest on that part of the coast, one of those little houses that look exactly like brooding hens, waiting for the brood to get in under the wings at night, and it had served at least three generations if not four, there were conch shells at either side of the front door, and flowers here and there.

Facing as it did directly out to sea, one saw all the vessels going in and out of Deep Waters at all hours of the day, all coming from or going out up to the great fishing grounds, or the "Banks" of Newfoundland as they are called, the greatest fishing grounds in the North Atlantic, from which the men for many miles up and down the coast draw their living.

Well, the dear people said they would take me in, and though the house was more or less disorderly, it was not unclean, and even if it had been I should have seen above all that, for the faces of the two dear people were beautiful as the afternoon itself.

There had been some sort of church trouble with the pastor and his flock, and since this dear man with whom I had begun to live played the organ in the church, he had refused to do so, and so on Sunday mornings he used to go into the little parlor with the hooked rugs and the crayon portraits and photos of the dead and the living, and after he had told me of the church mess, I said—well, Michel—you just play the service for me and I will come and sit with you, the which I did, and all of which was enjoyable, accompanying himself with his faint but liturgical voice.

On the third day of my stay which was to last six or seven weeks, four women came, two from the village and two from the island just off shore, with their spinning wheels, a sight I had never seen before, a sight even rare in these days, whereas in the earlier period every woman carded and spun her own wool.

I never left that kitchen except for meals and [to] stretch out a little afterwards, from ten in the morning until ten at night when the men from the island came over for their women and their wheels and towed them home.

These women had come over to spin up the wool for the hostess who had bad feet and had a great deal to do, and could find little time to do her own spinning. A great deal of local history was of course discussed throughout the day, the local church disturbances and of course the deaths, births and marriages of the immediate season, all told with reverence and without the sting of gossip, for they were all good women, as their fisher husbands were all good men, for it was a devout neighborhood.

It wasn't long before I noticed that the third woman was very beautiful with a most tender mystical face, her entire appearance being Gothic in its simplicity, her face looked as if she had spent her entire life in the soft gleam of ancient stained glass windows, lighted by the western sun, for every smile seemed to have clear light in it, and every silence a warm glow of faith, and her voice was gentle, which was not exactly true of the three others whose voices were raucous and somewhat hysterical which is often the case when women who live in isolated spots seem to feel the need of almost screaming to get themselves over. I settled for myself the fact that since this woman spun her wool so beautifully with fine rhythmical gestures, drawing out the yarn to the right length always, spinning an especially good strand, she would do everything else that way, she would have a clean house, the food would be good, the atmosphere would be sweet and kind, as my later experience in this household proved to me, one of the most elevating experiences of my life—in truth, the most elevating.

It was election time, and the young huskies were all off down at Deep Waters, tanking up and having a boisterous time swilling Demerara rum, certainly one of the most poisonous liquors ever encountered, and whatever else was at hand. Fishermen love these opportunities for the life at sea is hard and desperately cloistral, long hours, hard labour and various sleep.

I also met the noble husband of this woman who spun her wool so fine and he was equally remarkable—very tall, broad, strong, deep-chested, and deep-voiced,

and he too was mystical looking—very like a prophetic figure in Blake—this seeming to be their trait in common since husbands and wives that really love each other often get to look and think like each other, and no man and woman could have been more meant for each other than were these two, there was every evidence of having shared terrible labours and also of having shared sweet peace and goodness together.

The offspring of this goodly couple [were] likewise majestic, with the exception of one daughter who worked in the great city at a desk, and was therefore large-townish, and whose figure was superb, slight, svelt[e], agile—and walked with a very cultivated stride.

Two of their giantesque sons had died early in youth, one of them eighteen and weighing two hundred and ten, from common causes, so there were now two sons and one daughter at home, she too being powerful in physique and had the look and muscular strength of a man and bore the other half of the woman's work which is always hard in a fisherman's family as the men go out to sea at two-thirty in the morning, and the women must shift for themselves—no end of labour all day long for everyone, but all of it done with a kind of song in the throat and the soul filled with doing and not with raving about heaven or the Lord.

The hugest of the two sons weighing around two hundred twenty came to the house on the mainland during the election after having learned that Mackenzie King had been re-elected, arriving in time for dinner, eating huge platefuls of salt fish and potatoes, biscuits and whatever.

He saying to the host, referring to me, where did you get that bird—host saying—Sh—don't be rude, proceeding then to give me a hug round the waist pulling me to his stomach, making up to me, all of which was vigorous, archaic and new.

He lost no time in letting me know that he liked me and so we became friends at once. His long bristling hair black as tar stood up from his forehead which was low, six inches in the air and looked like ascending smoke from a forest fire, the flames being inside—him.

This giant who had calmed down a little from his Demerara debauch and with a stomach full of salt fish and potatoes and biscuit, said in a calm tone—we are building a speed boat over on the island, why don't you come over and have a look at her?

So, some days later a son of the mainland house who had a great pride in his own hair which was very heavily waved and deep red brown in colour, rowed me over in a dory. They were just finishing the hull that day, some of the machinery was in place and a deal more rum was being guzzled, and as the craft was still on her stilts, the huge head with the bristling hair stuck up over the side and said, come on in boys, and so we mounted the craft, and there was a great deal of pornographic talk, many awkward passes, much freedom of expression.

After an intensely exciting and original day, the entire set-up being so archaic and utterly different from all other qualities of life, it seemed as if we had to get back to the quiet realities, and so we climbed into the dory and rowed for the mainland passing a kind of honeycomb of very little islands just a few feet from each other with bridges across several of them so the inhabitants could visit each other or get to each other quickly in time of need or trouble.

Having met the other son who was powerful also, blondish in comparison with his dark brother, a few days later, I asked him to ask his mother if I could go over there and live, liking it over there.

Before long I saw him again, and he in his gentle voice said, Mama says you can come if you'd like to, and the shift was made to this incredible family unit which as I have said was to prove the richest experience of my life, the richest in ways that I never would have asked or believed. I shall not want ever again to live through another and pray the god of things it may never come to pass again.

I will begin to call names now, and they will be Canadian names very suited to them, and so the family was composed of Cleophas the father, Marie Ste. Esprit the mother, Felice the daughter, Adelard and Etienne the two powerful sons that made up this archaic and precious family, with whom I was to live and be so happy even in the august and all but killing presence of death to be told later.

Having enjoyed the remaining few weeks of that summer of my sojourn in the north with these people, I booked myself for the following summer which was to be a six month period, during which the exhausting drama was destined to take place.

There was a powerful fusion of strength and fortitude in these people, the father from the north, therefore with probable Norman ancestry, and on the mother's side there was diffused German.

Cleophas was tall, dark, and excessively handsome and I fell in love with him and all of his wonderful seventy years.

He had come down from the north with his brother who was as short as he was tall, very heavy set, bowlegged, and very froglike in appearance, and had none of the magic of his older brother, though he was powerful, materialistic, and shrewd, and had everything to say about the building of the boats and the buildings, as the other was devoutly pious.

No doubt of this early Norman ancestry when the French came over to discover and settle the land that became known as Quebec, and like so many seapeople inclined to wander along the coast in search of better chances.

They hit upon this just off-shore island separated from the mainland by a narrow channel which was always called the gut, and which provides fine shelter for their houses and ships from the blows of the outside winds, and so—a safe harbour discovered and very snug it is, eventually this was to become the little settlement of eighty or ninety people that it now is, all fishermen and their families of course.

These men soon picked out the women they wanted, both of Germanic origin, both women as different in type as their men, each man taking to himself the kind of woman natural to him.

Besides their ships which they built themselves, they built an eighteen room house—nine rooms for each proposed family, with a division in the center, that is—a small hall by which they could enter each other's houses without going outside in case of bad weather.

Cleophas was to father four sons and three daughters, and the other two— a daughter and a son, both like himself very dark and swarthy and very husky.

In the course of the years as families grew they established a functioning community of their own, with a huge barn for the cattle, a complete blacksmith shop with band saws run by a power engine, making all their own iron work and whatever was necessary for their ships.

It is all very hard work, this life of seapeople and the ever present dangers attending it, for you hear of drownings as casually as you hear of the weather reports.

There was never a time when there wasn't good conversation after grace had been said at meals, which seemed to light up the flaming robin's egg blue dining room with the black chairs, and the snow white linen, the talk was always started and kept going by Cleophas, added to by degrees by the two sons, and the women could be heard chiming in gently by way of simple assent, there was no vestige of hatred or ill temper and voices were never raised, never was domestic felicity more perfectly established, everybody loved everybody else. The English spoken was like their thoughts, archaic and elegant, rather inclined to "English" English at times, with here and there a strange fusion of low German chiefly in single words themselves, all from the mother's side of course.

Strength, beauty, love, and rich energy governed this household.

I was happy in being readily accepted into this family fold by this most eloquently simple people.

Fine Large Morning

When Cleophas said "fine large morning" it sounded as if a page of Blake had been blown open by the wind.

If I see him as others do, he is six feet one or two in his stocking feet and his powerful words seem to have an upraising quality and gave him for me a monumental height.

Cleophas is like an equi-distant quadrangle in all of his behaviours, squarish at all times, there is never any angular slant to any of his thoughts, he never resorted to the abuses of oblique conduct to cover up his oddities, for oddities he had none whatsoever and had little use for them in others, he liked only straight conduct— straight from first to last.

His body is as hard as the rocks and his hands being huge look as if they could take trees in twos and twist them together like rope.

I look at him as we walk among the pyrites glistening in the iron bound shale on one shore of the island, the which he digs out with his fingers, dislocates them with the press of his strong digits, see him break out of what seems to be like stolen sleep of thought into articulation and a boy's smile, feeling the translucence of his spirit covering me, I feeling myself growing bigger. I can't help this, neither of us can, we are two human beings together who have learned much in the university of the imagination, he from the sea—I from the little things on the edge of the sea, intricately enfolding, binding us together and I know it is a case of true unspoken love.

"We get along fine together don't we" he said to me one day—"yes, we do" I said—"and it will be like that for a long time."

Cleophas picked a fresh wild rose as we walked, a rose that had been opened but an hour or two, or with the early morning sun, so it was rich in its first roseflush. I thought he was going to put the rose in his cap, as his giant sons would have done, but he put the petals in his mouth and ate them.

"They taste good" he said, and after having done it hundreds of times I knew just

what was meeting his lips—it was as if a little red flame, the first flick of the fine large morning was burning in the middle of his seventy year old face.

He grew radiant with what was best that had remained with him all his life—"handsome, isn't it," he said.

I saw the petals of the new-born rose disappear between his teeth, and he seemed suddenly to glow within—then he twisted the calyx and the left leaves together casting them among the cucumber vines over the little hill in the garden, over beyond the light.

Cleophas is ardent in his belief that law is life and life is love, he lives a day of duty, beauty, and strength six days of the week, and on the seventh day he rests from his labours, which is given over to plain and translucent holiness.

"All that is within me, bless his Holy Name."

Cleophas is a natural mystic of the sea, which has taught him to be brave, fearless, trusting, full of faith—all simplicity.

These are the bright clothing that covers the soul and body of this man, and so I never tired of looking into his face, especially on Sundays for on those days there was literally a glow of heaven about him.

Sometimes, when the weather allowed, one or the other of the ministers from the mainland churches would come over and hold service in the schoolhouse.

I always went with the family to the schoolhouse because I could see the holiness and wanted to see it, it came from his face over me and I liked it that way, as I must have all things of that nature humanized for me, it is so natural—then.

It is Sunday, and the weather is good.

Now Cleophas has his black clothes on, his gold watch chain with a pendant compass spreads across his wide vest, you can hear the India paper of the gilt-edged leather hymnbook crinkle at his rough touch as the melodeon begins to drone forth, perhaps "Lead kindly light, amid the encircling gloom, lead Thou me on"—or maybe some other selection, as if he would say of the book as he said of the rose, "handsome isn't it"—and I listen closely to his earnest but slightly offkey tones, getting all the words in place but alas not the tones, but it doesn't matter, at least not to me.

The young minister of the white church over on the barrens has come over in a dory and gone back home again.

He might easily be taken for a street corner damnationist, as if he would tell you how he got away from the devil just in time.

He is an anaemic theopath, his body is wooden, his eyes are like fishscales and when he closes them in prayer they look open as the eyes of the dead sometimes look.

He is given to gentle but flatulent exhortation, he might be addressing a herd of seals who do no better or no worse than destroy the nets.

He knows of the two men that were washed ashore clasped in each other's arms drawn to their knees begging for mercy in a savage wind, and so they died lovingly together as they had lived lovingly together, for they knew that when two are gathered together their request is sometimes granted, they know the power if not the glory, and the misery, thicker and faster.

One of the fishermen once said to me personally in all sincerity, "What a gale it was then, and when it seemed as if we should all be washed away, I raised my hand, and do you know, the sea became calm again?"
I implicitly believed him.

Well, Cleophas—
 you know I was telling you about a remarkable moment I once had in the Bavarian Alps, it was somehow deferential and comforting—something came over me in the white world all buried in snow, just at the fall of evening, something whisked me away, completely enfolded me, I felt myself becoming everything—continuity, measure, surcease—I had become nothing and in that instant I saw myself perfectly—out of myself, and when I returned I heard myself saying to myself—wasn't it wonderful, now we can begin again.
I have had moments of glimpses like that at sea, did you ever have them, Cleophas?

Was it, do you think, the expression of the principle to protect the unity of consciousness from being split apart by the unconscious which is what directs most of our living—or do I talk nonsense, to you?
You remember we have talked over many things.
Thought came to me, it was this—to save the moment for the perfection of itself, that alone is intelligence.
Have you ever experienced one instant of clarity, I said to the trees and the flowing river, for there was no one or nothing else to whom I could talk, and having propounded the question I felt instantly foolish because they looked at me with compassion, as if saying, why that IS our life, we know nothing else.
In such a moment we have seen the beginning of the world, we are the world, it is ours and is ourselves.
So it was, Cleophas—when you said to me one day—"I want to meet you on the other side"—I could only ask where IS the other side, is it just over the left of the newfallen snow crystal that lights up the hand, making the hand seem miniscule and puerile?
Perhaps it is merely the other side of the NATURE in nature, or—"Where there is nothing, there is—God."

Secret of the truly flowering mind,
secret of the truly flowering spirit—
to live always on the edge—or near it.

This was as far as I could seem to go with Cleophas, and we looked at each other's feet and hands, and observed each other's countenances without visible emotion, thereby understanding them—
Cleophas, the loving, braving man, if not his arm exactly, then his
soul enfolds,
out of his wind-torn, rigging-worn face
surfeits of storm, gale, thunder,
flashes of lightning—clear, tender living
came forth, to its sacred place.
"We get on well together don't we,"
said Cleophas to me.

96

"Yes we do," I said, "and it will be like that a long
time,
we shall get on well for all, and ever"—
his smiling trusting seventy, all battle
and belief,
bringing me this wonder-warming sheaf.

"You and I get on well together, don't we—
why don't you build a little place here
for yourself, the lumber will be very cheap,
and we men will give you our labour."
It was good to know they wanted me with them,
"You love peace, and I love peace,"
said mystical Cleophas.

Marie Sainte Esprit

The mystical splendour of this woman was of an entirely practical quality, she did
everything right because form is an inspiring thing in itself.
She fed the pigs, the chickens, milked and fed and bedded the cattle, cleaned after
them, with this great sense of form and simplicity.
She mended everything with the same precision as an oriental rug mender.
It was as if she had swung some sort of a thurifer over everything as she passed,
she cared for all her animals with a natural abundance, all things increased
beneath the sway of her spirit.
The troubled became calm with her, and another life came to life out of her.
She was the appointed Mother of us all.

Sainte Esprit the gentle, the beautiful, bent over like a jack-knife at the wash,
after having had seven children, agile as a young beginning woman.
She was always dressed in black satin relegated to the common day usages, and
out of her universal white apron warm benefits came tumbling out into the lap of
a grateful world.
All animals rejoice and grow stronger hoof and feather at the lift of her soft voice,
all things increase beneath the soft pressure of her warm spirit, even her giants
and her flowers must be kept living and glowing with living, giants fed by heart
and soul, clinging to her still, staying the escape of their youth, as trees cling to a
cliff.
Swings from morning until night the gentle thurifer of the mother, nothing does
she disown, human or non-human.
She rises with the men at two, and sees them off, warmed for fishermen's
struggle with the sea.
Nothing will die so long as her rich heart lives, so wilfully in love with every little
thing, and then—some other little thing.
She is the mystic woman shape of her man, and carries the burden of the spirit ✗
with him.

Marguerite Felice

This names the daughter of this iron brawn that all but blinds her with its beauty,
for what this man and woman do is her full notion of beauty.
The sense of duty is for her like the shine on a sunlit fossil, it makes it handsome
by the shine it has, for lack of duty would be lack of beauty.
Out of the baking tins and shortening pails come solemn cakes and cookies,
solemn because there is no love coming into her life.
There is no man will take her, for men are scarce, so she seeks more duty to be
bright and proud for, she too having a large heart but a small way of pouring it
forth, because the magnetic fullness is all given to the mother and father, and the
giant sons, who are all day and all night burning with it.
Everything in the house is covered with crochet work, she mends the holes in the
towels, even sews the edges of the prayer book box and of course all the stockings
and the socks.
She lays three raisins in the cookie centers with all but geometric precision as if
the Lord had told her that precision is the most beautiful thing of all.
Life must go deep in somewhere, and so it goes to duty, everywhere.

Alphonse Adelard

What a spectacle is Adelard, if I hadn't known he was a human being, I should have
thought him some devouring beast from the caverns and the caves, all of his thoughts
emotionalized and dramatized by magnificent, opulent, voluminous body action.
He is tall, huge, giantesque, and his smoke black hair stands six inches above his
low forehead, making him seem all the taller, almost spectral, he—the most
Norman looking of them all.
His eyes have the famished look of one never to be appeased, of an under-eaten,
over-ravenous wolf, sniffing at the mouth of dungeons, or at the edges of forest
fires, loving the pungence of the burning vegetation, sniffing it all in with lustful
eagerness, for Adelard, life must literally burn to mean anything at all.
He lives utterly for the consummate satisfaction of the flesh, the kind of flesh
making no difference.
Wrists thick as the butt end of an ox-yoke and for whatever it takes two to tear or
lift, he says "nonsense—give it to me" and if it is a rock out comes half of the
world with it, the entrails of the earth lie bare, and beneath all his strength lies a
heart as tender and as beautiful as that of a young girl.
You must be prepared for the eruption of his Vesuvius, for his laval heats and
flows will inevitably inundate your careful and calm city, you will be different
somehow after he has left you, if it is only that he has said hello.
Adelard is a beauty because he is powerful and as true as he is powerful.
He has no common codes, no inhibitions—he will give as much love to a man as to
a woman. He was totally loved by all of them up and down the coast, and because
he was thrown over by the first woman, I think he has transferred his affections
to his men friends, for he loves them and will do anything for them, and with this
comes no mercy, love for him being the outpouring of his devastating energy—all
flame, smoke, fire, steam and animal hissing, he is thunder and lightning in one,
and loves when he strikes—it is the measure of his common quietude.

Etienne

Another measure of strength and gentleness comes here in the smaller but
quieter son, and likewise giantesque—by no means as tempestuous as Adelard,
but smothered within an inward burning, which when it comes to the surface is
lyrical, probably because he has inherited the lyrical side from his mother—Marie
Ste. Esprit.

He is well inclined to blonde, his arms, legs, and hands are huge, he eats one
quietly but passionately with his piercing blue eyes, and while he looks he smiles
as if saying to himself, I like the look of you, and every word you say, everything
goes down into the very bones of his memory.

You must succumb to being translucent in the presence of these people because
opacity is an enigma to them, for everything you think to hide will come to the
surface, and show you for what you are—for life to them is a sort of living
sacrament.

When I made my bid to go and live with these people on this island, Etienne said
to me—"You will love the perfumes of the garden, and the singing of the birds—
we are very happy over here."

Canadians as I have encountered them on these Atlantic shores are a warm
wholesome people, their various bloods giving them a freshness and aliveness,
and there is a tang about them like strange new fruit, once you like it you want
more and more of it, and so it was I liked equally the different pungence of
Etienne, as of the others, and the beauty of it all was that I could feel myself being
drawn in from day to day into the meshes of the special and singular affections of
these people and if you loved these two giant sons in their soberness and their
shy simplicity, you could rave about them in their drunkenness, for that was their
one vice, if vice it was, and as the two brothers loved each other if they went on a
drunk, they always went together, and they swept town, village, and shoreside
with their overwhelming geniality.

Sometimes these drunks would last for days, but eventually the boys would show
up again in the family circle, ashamed of their lives, to present themselves in front
of their parents whom they worshipped and since they were thirty and thirty-
two respectively, it was a recommendation of their childish innocence.

But nothing was ever said by either of the parents or any look or sign given, and
they would eventually go to bed and sleep it off, and come up to the surface again,
ready for hard work and plenty of it.

Etienne was lyrical as I have said and shy, as Adelard was tempestuous and
dramatic.

Jeanne Marthe

Here you had a completely different note, for this daughter has been sent to the large city for a commercial education, and it is surprising that she is the oldest, because she looks quite the youngest, always seeming as if she had just come from tennis, from fencing, or perhaps from a Junior League meeting.

Her figure is tall and straight and supple; every part of her is in tune with her thought-pierced eyes. She has the face of a Portia, serving judgment secretly by being punctual with very plain, sure words.

It can be imagined what she said to the Portuguese fisherman who followed her from the island school to the cove when she was a girl. According to report he was handsome—poor lad, dead now, drowned at sea, leaving a far different wife and some children. How romance plays the devil with so many hearts, it often happens that men wear very different images in their imaginations, on gold chains, than the image they look at all day or after work.

"I do not want you to follow me anymore"—and so the Portuguese went away and was never seen again on those shores, couldn't bear to live there and not follow Marthe from the school to the cove—"You are not and cannot ever be the man for me" is very likely what she said.

A different look is in her face as there always are when decisions have to be made, in matters of love.

It was like that with Adelard too, as I have said—his woman went off and married another man, maybe a man that was softer and looked gentler than Adelard, less ferocious, and Adelard was never the same again, and this is doubtless the reason he was so utterly tempestuous and devastating—one had the sense he would come to some destructive end.

There is another daughter not to be named here, I knew that she had ex-communicated herself from the love of her parents, by some disrespectful act, she was never spoken of in my presence, or her name spoken by anyone.

Evening by the Seawash

A single rake is slanting up to the sky, it is the last day of haying, the oxen are pulling in the last load, all the men and the women of the family are returning from the field, save Adelard who, being a mechanic, was putting an engine in, in somebody's power boat.

He came to the kitchen sink, stripped to the waist, and [said] to me, "here please wash my back," and so I washed it for him, it was like scrubbing an acre of granite.

The oxen and cattle are now in their stalls, the cows have been milked, all have been fed and bedded, and the calves put carefully in their stalls, their chops drooling with new milk.

Swallows sweep in and out of the great barn, in and out through the large door and through the empty window spaces.

There is a nest inside the door so close to the nearest cow, you wonder how even a swallow could be so trusting, for you can reach into the nest, so close it is—I did—and found four soft things that seemed to want to prolong their adolescence, so cosy they seemed, opening their mouths as my fingers approached them.

The men came at the close of the evening with their scythes swung to the right of them—Cleophas, Etienne, and the others—for Adelard is never in the field, or in the fishing boats—for he is a master mechanic down in Deep Waters.
Seafroth clings to their thick male lips and scythes, a cow's horn on the hip of each man holds the whetstone resting in a little water.
The women come in their own file, eating new strawberries.

"Pas une atome de nature que ne contiene pas—la Poésie".
<div align="right">Flaubert</div>

Down they go over the rocks, the women watching their men go off to the high seas, to the terrible Banks, not knowing whether they will return—some never do.
They snigger as they stand a while as if salt tears were of any avail, they shed them—picking up their pails where they left them, smile a little and wave hard-worked hands, pick a wild rose or two smell them urgently, perhaps eat a strip of salt cod on the way back, the evening light still warm on them.

Watching the crows at the sealap—digging in with their shiny beaks in among the silt and the bywash.
Mercy, Lord—will they come back, our men—or will they too like so many—follow the floating rack of the sea?
There are no crucifixes or bleeding hearts or medals of Mary, for these people are not Romans.
There are likely to be portraits of Queen Victoria, or of Edward the Seventh, or now of George the Sixth, accordng to their generations, and of their new queen, Elizabeth whom they very much like, for she is very gracious.

Constantly October

It had been such a long lyrical summer, and then it came September, September crashing down upon our hearts and souls like earthquake upon ruin.
And then—it was constantly OCTOBER—and now it must remain forever October—the lonesome OCTOBER of our most immemorial year.

In the village a child was born, it was not a wanted child—a young man was married—an uncle died—so many uncles in small places, leaving their small traces.
This uncle since a long time wanted to go—couldn't go—and then something said he could go and so he went, and like a miracle he was found to have a sweet smile on his face, the smile almost of a young girl, for he always had had pink cheeks and a fair face.
Many came from the mainland, and all of the island, and the two ministers came.
I went to look at uncle whom I had never known, chiefly perhaps because I had not looked for a long time on the face of the dead.
The face looked like a cross between John Donne and Frederick the Great, but it was the face of a fisherman with the smile of an adolescent over it.

Puffs of silk touched both ears and a silk look shone down the edge of the thin
nose as the afternoon light fell gently on it—the I.O.O.F. button in the lapel was
the only other shiny thing.

Many flowers with chiffon fluff bows, cards fastened to them, many cloth
flowers that last longer on a grave and would no doubt look real enough to the
eyes of the dead.

Then it was over, the ministers said things inside that I could not hear as I was
standing out under the trees with his pals, the other fishermen—then they took
the little man in a long grey house down over the rocks on their shoulders, laid
him in the center of a large power boat, which was once a rum running boat, then
everyone who had a mind got in and the cortege sailed slowly down to Deep Waters.

After a while everything got to town, and there on the dock stood a cluster of
men in abused top hats and worn plush regalias, and then one knew the little man
was a big man, for he was one of the founders of the local I.O.O.F.

There was a solemn parade through the main streets of Deep Waters into the fine
old Church of England, more things were said out of books mostly, and then the
little man was taken to a quiet place.

All of September passed, and then it became October—the period of falling
things, of disintegrating things, and of terrible heart lashings.

The Wind

One day a terrible gale swept over us all, up from the Caribbean and Florida, they
said it was.

Trees lashing almost over to the ground, the seas drowning the gardens—the
swamps deluged with rain.

It was Saturday, the day when Adelard was accustomed to come home for the
week-end from his mechanic's work in Deep Waters.

Etienne was likewise in town, and with Colin Alain the pretty little cousin, were
expected before the black night fell that was to be so devastating to us.

Sunday Morning

And the boys still not home, eight, nine ten in the morning, and the boys still not
home, and the waters and the skies as calm as calm.

As the gale rose in its fury, Uncle Pitou on Saturday tried to telephone over to the
mainland to hide the punt—had he not told Adelard time and time over that the
punt would one day be his coffin—and all the wires were down. Adelard would
never come over in a dory for he loved his eight foot punt, and piercing to relate,
with five hundred pounds of men in it, what good would it be in a terrible wind.
The wires were down.

And so fate was to follow in sequence in the manner of a Greek tragedy from one
inevitable point to another in the exact measure of the theme.

Blow on blow of a hard fist from morning until evening and—then—the next
awful day.

The wind tore round and about us surely at seventy or eighty the hour, firs and spruces nearly bent to the ground, here and there one uprooted, the gulls having early sought cover among the shelving rocks on the off side of the shore, spears of rain descended, piercing the garden without mercy.

"The gale will last all day," said Uncle Pitou, and would subside before morning— morning would be Sunday and calm.

It was not calm, not calm in the human soul—that is.

To be sure the weather had subsided, but the heart-racking drama was to begin.

At ten o'clock Sunday morning Adelard, Etienne and Alain had not come home.

"Something is wrong," said cousin Pierre, "I'm going over to the mainland and see what's up."

It was all up.

The punt was not on the shore, the boys had not stayed over-night on the mainland as they were often accustomed to do, the car was in the garage showing they had come that far, but—no punt, no boys and no news.

Inquiries eventually located the punt twenty miles down shore with all the boys' things in it, including the Sunday groceries.

The shopkeepers in Deep Waters who knew the boys well begged them not to go until morning. "Hell no," said Adelard, "nothing but a breeze," the air odorous about them with Demerara rum and he Adelard, thinking of course of another chance to dramatize himself, got his chance good.

No punt, no boys, no oars, no clues.

DROWNED—was the one word spoken—DROWNED.

Poor lads, torn with the truth from an awful sky.

The dark woman down the shore a piece knew all about this, for her man had been taken from her in a much worse way, she who was raising mink to help raise the children.

Many families lose their men with the wind, but they lose them far out to sea, and so they know it, as the fish boats every now and then go down taking all hands.

But this was a mile from home only, set for a spectacle to break us all in two.

It's all done, that's what it is—it's all done, and so it was all done—the wonderful Adelard, Etienne, and their pretty little cousin, GONE.

Grapples were hauled out, and it was something too much to see the great prophetic looking Cleophas staggering over the rocks to get into a dory to go over to the mainland to see what might lie before him, or rather what was not to lie before him.

And the dragging was begun, and for three days no sign, and everyone said, they have been washed out with the tide.

Here is a small story hardly to be believed but true.

On the following Wednesday a fisherman who had been grappling during the past three days and who lived at the south end of the small islands said he had a nightmare dream—he saw Adelard and little cousin Alain, lying on a certain stretch of sand near the upper bridge.

It was nearly dawn, he got out of bed on waking, put on his clothes and his rubber boots at the break of daylight, rowed straight to the stretch of sand in the dream, and—found them there together, just as he had seen them in the dream, showing they had struggled with the seas, for Adelard's big hands were clutching seaweed, showing also that Adelard would do all he could to save little Alain whom he loved—Etienne, floating somewhere alone.

Etienne's frail little fiancée, a pathetic little school teacher, wanted to go down to the island Saturday afternoon for the week-end, and if Lucette had gone all would have been saved, as then they would have had to go in a dory and all might have been well, and we would still have those powerful and magnetic men with us, and life for all would be very different, but Lucette's mother begged her not to go, and so she stayed home.

I did not go over to the mainland after Adelard and Alain were found as I am soft about such things, but from the stories of the sea men who are all hardened to such things, the sea had done a thorough job, they were badly mutilated by being thrown against the rocks, and the fish had eaten their good looks away—there was a look of grim determination on the face of Adelard despite the disfigurations, the face of Alain was bruised and calm.

Double Funeral

And the church filled with men of the sea and of the land, surely three hundred of them, for Adelard was famous on every stretch of shore up and down the coast—he loved his fellow men and was deeply loved by them—he had raised hell with them all and been sober with them.

It was as if the seas had fooled with the boys enough, and had said you do the best you can with them, I don't want them.

There was an abundance of flowers on both biers, the paper ones quivering with the small breezes.

Two thirds of the tragedy was over, and it remained to find Etienne somewhere out among the waves, gentle as a lamb and good—Adelard all theatre and never a harm done.

"Doesn't seem possible" said Felice to me—and all I could answer was, "It hurts me, for I also have lost something—great human values, powerful, gentle, decent, loving, truthful."

It was written in the book that Adelard would come to some violent end.

When the woman had turned him down, he began to be wild and turbulent and violent.

Big men are often foolish like that, and whatever it was it went down deep inside him and killed his spirit.

When he drove his car he drove at danger speed—"how many times did I tell him," said Uncle Pitou—"that punt will one day be your coffin."

By now everyone has gotten themselves into the key of the wrenched and broken heart and a deadness of soul was over everyone and Etienne the "angel" as he was sometimes called, still floating and floating, and some said by now he would have been washed out, and nothing of him left.

Some of the men said they had to go into Deep Waters in the boat and would I join them, and for some trivial reason a little later I decided I would wait until another time.

An hour later the boat had hardly got out of the gut when word came—"he's in," and the wounds of all hearts were opened wider and wider.

If I had gone I would have been obliged to face Etienne floating, sea devils having taken the best of him, his hair, his lips, his face, and here we were, thrown up against the rocks of misery again.

The evening-faced mother all but dying in her heart, could sit up no longer, and had to lay her down—and O the look on the face of Felice—sometimes it seems as if mother would go too, with so much of her spirit, blood, and strength drained already. Somehow or other some of us could eat a little, so we sat in our black chairs one either side of mine, blacker than ever, the yawning white table cloth staring us in the face, some grace as usual at meals with the light and the heart gone out of it, a kind of leaning toward each other for support, it is like that in fiercely great moments, and I learned for the first time that grief could take on an epic character. We were shaken, three times shaken, and when the sea was so calm and gentle next day, all I could think to say was—"How could you—how could you?"

There was the funeral of Etienne shortly after he was found, a quiet gentle affair, none of the glamour of that of Adelard, for he had swept all the men of the surrounding country off their feet by his strength and his unbridled lovingness, and then Etienne was laid quietly by the side of Adelard, and they went into everlasting sleep—the gulls were flying softly overhead, and the paper flowers were rustling unmindfully.

Strange—how one can get used to things, and somehow we began to talk to each other—it seemed the only safeguard.
Cleophas did two things at once, he sold the car and then sold the speed boat Phantom—what a name, nice name for all this trouble—two men came down from up the coast far away, "take her away," he said, "and don't ever let me see her again."
"You will go on Cleophas," I enquired, "of course you must go on, after all you are a young man of seventy—seventy is nothing for a man like you"—and he softly replied, "we have made up our crew for the next fishing season, we have got to get by such things."
And when the great black cloud had rolled away on a nice day in October, there seemed to be an air of cleaning about the house, and great armfuls of hooked and braided rugs and clothing were being brought down from up stairs and put on the line to air by giant Felice.
I can tell you what the armfuls were—the awful armfuls. They were the manly shapes of Adelard and Etienne swinging ghostlike in the sun—coats, trousers, jackets, reefers, caps, mittens, woolen socks of two sizes, two wraith forms waving on the morning air, every article displaying a certain determination to retain its identity and moods of two strong things in life, acres of strength, acres of gentleness, acres of soft good heart, acres of childlikeness, two men whose images were hung out on the line for a little sunlight.
"There is nothing left," said a pal of theirs to me, as I sat with him at the gravesides, weeping brokenheartedly, tearing some of the paper flowers, "nothing left, the bottom has dropped out of the island and the rest of this coast. What shall we do without them, nobody, nothing to measure up to them"—and I put my arm around him and led him gently away—
"Come," I said—"it won't do for you to go on like that," and then he broke down in weeping again.

Departure

It came time for me to make decisions, to cast an eye southward.

It was snowing and the earth looked as if it would be buried under, the flakes falling on everything as carefully as possible, as if not to disturb the recent pathos of the scene.

So I began to prepare my luggage as quietly as possible, and guessed Sunday would be a good day for me to get back to the mainland.

We had Sunday dinner in the room with the stark blue walls and the black furniture, and the mournful white table, and then toward mid afternoon Marie Ste. Esprit broke down in tears and said—"will you ever come again?"

"Of course I will," I said—she putting herself in my arms, weeping copiously.

The great Cleophas straightened his shoulder, hitched up his trousers, pulled at his long rubber boots, put up my heavy bags one at a time, carrying them himself over the bridge down to the fish wharf, letting them down one by one by a rope and pulley into the waiting dory for it was low tide—then I let myself down, two of the boys across the gut having come after me to row me over to the mainland, a little rain, a little snow pelting us all the way.

I shook hands with Cleophas, his hard hand clutching my soft one earnestly, then descending into the dory, smiling back up to Cleophas with as much smile as I could conjure—there he stood like a monument of beauty and anguish as well as power and simplicity, humbly twisting a piece of rope between his thick fingers, saying "If you ever want to come back again, you will always be welcome."

"Cleophas," I said—"be patient, I will be back, you just wait for me—be patient, I will come" and we went out through the gut to the mainland, in a little rain, a little snow.

Five magnificent chapters out of an amazing human book, these beautiful human beings, loving, tender, strong, courageous, dutiful, kind, so like the salt of the sea, the grit of the earth, the sheer face of the cliff.

I went to the cemetery before I left, I told no one, I didn't want anyone around— the seagulls swirled over my head, the breeze blew furtively around my body, the white fence showed where their estate began and ended, I looked down into the earth as far as I could and I said, only the seagulls hearing—

"Adelard and Etienne, I loved you more than myself, I love you because I was equal with you in every way but the strength, and it was the strength that fortified me—I truly loved you."

I did not wait for plausible replies, I could only hear the wind rustling among the paper flowers, twisting their worn petals east to west.

Fisherman's Last Supper

For wine, they drank the ocean,
for bread they ate their own despairs—
counsel from the moon was theirs,
for the foolish contention.

Murder is not a pretty thing,
yet seas do everything to make it
pretty
covering over the burning sting,
for the foolish or the brave,
it is a way seas have,
without remorse, or pity.

Dying by washing away
hot fires of plain men in them
washing away to nothing in them,
washing away.

Bound with the thongs of sharpened
might
whipped are the throes of their
muscle-might,
horizontal now the shape of their
delight,
grey lengths of still wonder,
crushed by overt thunder.

Plate 7
No. 94 [Adelard and Etienne], ca 1943.
Pencil on lined paper, 7½ × 4½"
The Marsden Hartley Memorial Collection,
Bates College, Lewiston, Maine.

POSTLUDES

To the City

After the dark things were over, and the flowers of paper had done their last rustling, and the real flowers lay down to rest also, the clothes had been hung on the line, you can see the great stalwart dutiful Felice bringing armfuls of solid clothes down from the upper chambers, only Felice could have done this, and the watch that said three minutes to nine and a gold one, was put away in an upper drawer, on a certain morning we all went to the city of Deep Waters, the women to buy provender and woman things, one man to buy shingles, and Cleophas the oldest and most beautiful to sign legal papers as if legacies might do something to settle an awful thing.

We went in the big boat and it is always nice going in the big boat for there is plenty of room in it, plenty of room for the wind to get into the sails and it is nice going under sail, without the thud of the auxiliary engine, for you hear the soft lapping of the waves, the rustle of the sheets, the straining of pulleys, and the sounds make one think of Nordic legends where all was fighting and love, disaster and storm, sunshine even, as death takes on the quality of legend which removes a deal of the pain.

Two of the men took to drinking again after two weeks of abstinence, as it seemed as if they could cover certain losses by going back to drink again, and certainly through the swift transpositions of the brain they could have brought Adelard, Etienne and Alain back again, they could sense them clear and loud and enveloping just as they were when they were actually living, and it was this that made them live again, as if nothing had happened.

You could hear Adelard bellowing aloud again with his velvet basso voice, talking loudly of speed and action and the consuming fires of powerful speech, and you could hear dulcet whispers of lyric calm, and that would be the voice of Etienne and you could see him put a flower in the hand of the friend he loved—"you must have a flower," he would say and put it in the hand of the elder friend, you could hear him say, "that is for you"—and the friend would take it, hold it in his hand, and he would say to Etienne, "put it there," pointing to his cap or his buttonhole because it all had to do with what Etienne was thinking about his friend, and if he were drunk enough he would put his arm around the friend and kiss him earnestly on the mouth, which he seemed often to want to do, but being sober he could not quite make the gesture, because he would be self-conscious of what he was doing, but when drunken, not.

Someone would be looking if he was sober, he was sure to think.

And one day when a young and lascivious woman saw him near his friend, and saw him put his cheek right next to that of his friend, the woman said, hoping for something unusual—"why what's going on here"—and the friend protectively replied—"O not what you think, get out, you bag of flesh."

And then, nothing could be said, and everyone in the end would have the right look on their faces as if the right thing had been done.

Who knew better than Etienne and his friend, what right thing had been done?

■

Lie folded now,
never mind dew,
wind, rain,
press of snow
clutched seaweed
for last tryst
O break of
freezing breast.

Two men are flattened
and the little one lay near
smiles now are battened
with crusty width of wind,
nothing can be kind
with this in mind.

What is stalk
without flower or seed
nothing but stalk
choked with weed—
what can be bread
without heart of wheat—
O boys—you have nothing now
to meet
what we have to meet.

You had a dream
delectably begun
all ended now with implacable
punctuation—
to us it is loss of breath
with connotation explicit
you should not have
tempted—death
So it is—you too
are lost for breath.

It Is Like

It is like another evening now, though it is only afternoon.
Life is different, it is trying to begin again, because it must begin again.
Adelard, and Etienne and Alain, have only gone duck hunting up among the small islands toward the north.
Everything must begin again.

There is a wind and it blows the chickens sideways, till the small feathers turn back and look blacker than they do straight, for straight the light on them looks a golden brown.
The folks have all gone over to the racks because a cast is in the sky and says it is time to take the fish in, so they are all, men, women, and children taking in the fish and piling them high under old sailcloth.
The racks are long and they are backed by old lobster-pots clotted with crab-shells and sea-trash.
Now all the fish are taken in again, the chickens are going with the wind now, making their feet look yellower.
Perhaps it will be a trifle colder, but life just must begin again.
Adelard, Etienne, and Alain have only gone away duck-hunting up among the small islands toward the north.

Taking the Oxen to Good Grass

About August each year, before the boys went, it was the custom to take the oxen up the shore to good grass.
"Would you like to go with us," said Cleophas, "We are going up the shore to take the oxen up to good grass," and I went with them and saw a most original spectacle.
They tie two dories together side by side, tie them very fast, fill the bottoms with hay, then drive the two oxen one by one into the dories, their fore feet in one dory, and their hind feet in the other, and they tow them up shore with a small power boat to a clear, calm landing place, the oxen chewing their cuds calmly.
The fields with good grass were wide and high and lush, and there were many other oxen there grazing, and there were many mushrooms in the low grass.
I being no sea man, could not jump from prow to the rocks with the same skill, so Etienne said—you get on my back, and took me pick-a-back to sure landing, and I can still feel the heat of his shoulder blades on the inner sides of my legs, and then we walked through the fields and down a shady road, and ate apples all along the way.
That is something you would never see anywhere else, but they are like that up there, full of original ideas, archaic behaviours, rich in wholesome flavours, they are kind and gentle, and beautifully mannered.
They are a sweet people.

Voice of the Island

This many pointed island lost
most of its wealth last week
in a wind.
"Many birds perish on the way,
savage winds beat them into the sea"—
So runs the lyric treatise on migration,
they are thrown out of their earthly station
thrown by the wind against the light
shaken of the blood and their might,
of their quick breath and loving looks
you sometimes read of this in the very
best books—
so it is, as we come to look over
to the fir and the hemlock tree,
fixed in missa-solemnis duration.

Our three, and this was the best of all
the threes
were beating much too hard against
fierce discus of the moon
and what they thought too foolishly
was boys' square victory, was nothing
but obtuse derision.
If we think now, of this algebraical recognition
shall we ever again achieve geodetic decision,
we have no sense of latitudinal salvation.

Islands live their life in single,
usually
single bliss, single deprivation, single
connotation—
every now and then the wind takes them
shakes them, punishes them, almost
breaks them
with the blowing out of the breath of their men,
dark takes them to obsequious solution—
leaves island shivering, quaking, to its
lonesome heart-breaking
wind-shaken of its men
without recourse to planet consolation.

The women moan within their habitation
marrow is struck in every spine
my child—my child—says shattering one
couldn't be no harsher, says sea-stricken
other,
she too being devastated mother—
Remainder talk of how it should not have

been, or be—
know winter will bring heartwrench
austerity.

Three out of one island, the very best
three
of all the radiant threes—
too much, too much, too much—another said
and shook her sea-stifled head.
Of fine insurance others had it true—
will Cleophas give up the sea,
now his two are the saddest portion
of three?

Sea gives whimper—can't do anything
with them, now I have them—
you take them earth, you thought they were yours
I thought they were mine.
Now each has something to determine.
Earth says—give them to me—my breast
is calm and wide,
I have old enough, the young will give
fresh pride.

Sails will go by, gulls will go by
gulls will say there's the rock they
broke on
who will listen to their fishtongue talk
save here and there the stilted crane
out for his evening walk.
News goes quietly into dust,
men take their time but they go too
something in them stirs a lust
for holding on to see what flashing
signals throw;
keep to the right, one way street
they set their pace and go a single way;
these three are gentlemen of leisure now.

They've checked their coats and let
their hair blow back
facing a single track—
White fence will show them that
the race is done,
too soon, too soon, too soon;
others sit measuring grief with dividers
until the inches take a foot
sending stale words on sharp gliders
words from thoughtless root.

October is the month of questioning
will winter bring something like
the same thing?
I wonder, I wonder, I wonder—women want
to sing, and find they cannot sing—
nothing in the meaning of a chant
nothing in the groan of quivering bell
sweet sound nothing to the ding
of waves
stiffened in their own imagining—
glint of trusting crow's wing, takes time
to tell its tale—what tale to tell
of things uselessly immortal;
we hear three young ones say to this
I gave a certain constellational love
why must moment falsely prove?

Now we must stay October minded
with shocks of love and pity blinded.

Breastplates for these iron men
made still with firestone distress
flowers for the breasts of men
pretty flowers, breath-shaking flowers
crisped with madness of the hours.
Safe in the arms of—O heaven
why this sudden bursting leaven
of despairs
in eyes and hearts of men who loved
these men as women sometimes can—
whole flanks of men made brave for tears
the long thinking of the years—fishermen's tears
strips of black over biceps thick and warm,
October in their saltstrewn eyes
thinking to invest some width of comforting
strategies—
eyes look down into certain man-sized space
what a place, what a place, what a place—
handful of earth, when of earth there is too much
what is certain earth's worth against
twisted clutch
of heart pain.

Adelard the fearless,
Adelard the brave,
who, if it was for love he dared
a thing
any little thing like love to crave,

stopped at nothing it to have,
what was hurricane but fleawhisper
to a man like this
in search of thundering bliss—
home in mind, friend, lust of October sun
which is sometimes kind
when matters are already determined—
if he said "off" to blast from north
he reckoned little what blast was worth,
how reach these hurricanes we
when they have will to terror—
thunder in a spruce or fir,
none but demon murmur.
Adelard took out, no sail or sprit,
and then not oar—two others had
thick sense of it—
Etienne—Alain Colin
three were iron hell of a man
three took off in teeth of gale
none more than twist of universal gale
that nobody will deny,
for we
thought this was enough to stave catastrophe—
sea is something children cannot play with
has jaws, wings, arms to flay with,
so simply took our jolly three
to vicious, clandestine travesty—
three to bravery's arms,
three to mortician's charms—
now, peace is sterile
for who know too well.

Wind shook them, sea took them
gave their dream a sullen twist
what consolation-less tryst—
night broken, the beautiful thunder
in their bones,
made misery in heaps for miserable ones—
love gave its bruised hand, maimed
with passionate grasping,
three messages no one was asking.

"I love" was written in the mouth
of each one
in everlasting spencerian—
you who loved most must
take this word for your own
in sacramental trust.

Prayers beneath the sea
are of no avail, mystery woman
you can't smooth thing over with
nectar out of broken pot
you may think you can suffocate
the pain—mystery woman,
you can not.
Prayers are of words,
deeds of something done—
may be three think they have won, woman
but "lost" is the shattering cost
by every bird wing suffered, carried,
tossed—
Lost is the breaking word,
Found—the terrible inferred.

They keep returning

We could stand perhaps
blowing of grass
and last flames
of amaryllis.

If only visages we knew
and shall forever know
wouldn't up-blow out of them
visages that leave smiles
twisted in grass
at stiff pointing
of compass.

We could stand perhaps
lofty posing of spruce and fir
calm flowing of seariver
beneath bridges, that laps on shore
and breaks to sharp whisper
of ways it was before,
O whisper stark—of shore.

We could stand perhaps
to face run of days and whirl
of sea-gull, clipped swirl
of wave,
plain wonder of each thing,
brave.

If grasses would desist
not forever blow and twist
smiles to threads we knew
before wind blew
tearing love to shreds
torn from soul sinew.

We could stand perhaps
look of snow here and there
in crisp streaks of sky
giving signal of quick winter—
stopped whisper of grass
snow to blow, tell grass
be still a little—rest give us
from stark whisper,
a little be still
from stark whisper.

We could stand perhaps
major of it—if only minor
wouldn't press on diapason key
so,
or if it wouldn't matter to let secret
blow
over rock and crest of barren moor
how else have rest from pain of minor
throb and throw.

Smiles from out the grass say,
come hither, let us wrap you round
on the old, tried, common ground—
let us make worn, torn places smoother
with our tendril traces
heal broken places
of steel murmur in severed places.

Fishermen at Bread and Wine

Two men, a small, a great
two men whose heads bear light
from strange light—kneel
in schoolhouse, certain nearness
to feel—
whose bread and wine are being favoured,
hands, lips, when chiefly salt
and death by wind are savoured,
take, eat, and remember
and speak no sound of miracle,
after.

I see them sipping of cup, and eating
of the flesh all day,
as if there is in silence there is
thrice sweet to repay—

They do this "in remembrance" at their
work, and at their play.

You'll never find them unaware
of what is in the nest,
wickeder the sea, holier it gets
something is there, something is there—
it is the POWER, they say
that brings these noblest two to prayer—
seventy to the one, sixty to the other
there is the unspoken word of 'brother'.
Unspoken—lies miracle therein
of what they ate, drank, and quietly
remembered—
purest of the pure, upon their lips
each soul so tempered.

Fishermen

I saw two lovers laid—together
in October widths of neighboring ground
the wind has taken all their choking breath.
Two sons they were, of the same stout feather
each had loved a separate, lonesome thing
one had taken to his breast a wisp of woman,
the other, wild beast's roving notion,
Harpstrings in the voice of one,
to make stout heart rejoice,
and in the other, dash of sea in a
cliff dungeon—
two that were warm in every brace
of bone,
one had found and lost his woman—
dark thunder in the stride
of him who lost with play of dice
for love
spring smiles were in the eyes of him
who strode the deck of his boyish theme,
with world his heaven to prove.

"I'll have them both," said raging sea,
and took these lovers to his water strategy—
they'll bring a wealth of warming down
to those who live in water dungeon
who peer through twisted lattices
of moon.

"si tu n'avez pas connu"——

So long, my five beauties, whose lives
enlarged my own.

Notes

Hartley's fictitious names for the characters and places in the narrative and their real-life counterparts are as follows:

Cleophas	Francis Mason
Marie Ste. Esprit	Martha Mason
Alphonse Adelard	Alty Mason
Etienne	Donny Mason
Marguerite Felice	Alice Mason
Jeanne Marthe	Ruby Mason
Deep Waters	Lunenburg, Nova Scotia

Hartley's friend, Frank Cyril Shaw Davison (1893-1944) was a native of Hantsport, Nova Scotia, who wrote under the pseudonym of Pierre Coalfleet.

The fishing village to which the cab driver took Hartley was Blue Rocks, Nova Scotia.

The Mason home where Hartley was boarding is located on East Point Island, Lunenburg County, Nova Scotia.

The drowning of the two Mason sons and their cousin occurred on September 19, 1936. Hartley remained with the family at Eastern Points until December, 1936.

G.F.

Plate 8
No. 87 [O Bitter Madrigal], ca 1940.
Pencil on paper, 10½ × 8″
The Marsden Hartley Memorial Collection,
Bates College, Lewiston, Maine.

Related Poems

Two Drowned at the Gateway

They walk on the waves at night—
all day they sleep beneath;
one wears a lantern on his brow,
one wears a wreath made of quivers of the sun.

One had learned what love is,
had pondered some of its frail mysteries;
and one,
one had not yet learned
how it was to be learned;
nineteen and twenty-two,
lost at the gateway.

The mother looks out of the window
each misery night;
she sees the glow of the lantern on the brow
and hears the quivering of the wreath.
Why do they walk and shine in the night
when they were so beautiful by day?
Says she to each: "O my glimmering boy,
will you not come
where it is warm?
It is cold facing the night,
it is so cold in the night
I am frozen with fright.

"Will you never come to the hearth again,
my gleaming sons
my precious men?
I hear nothing but the moan of the wave
and the windgroan."
When it is darkly dark
she sees the gleam of the lantern,
she hears the quivering of the wreath
again—shadows
these two that yesterday were men,
her own little children.

O Bitter Madrigal

The ventricles of his heart burst
like a dyke upon the world of his
simple things
and the blood of his being flooded the
fields and valleys, leaving wide wake
of grief upon parched places of earth.
O bitter Madrigal!

Sing not O bird upon my shoulder; I have
no ear for sensed logic of peace; I am
broken in two; the world and the dream
split in two; the rags of them trailing over
my aching bones, my lips suppurate with
gall.
O merciless Madrigal!

Who is there will come to tell me how
to live, letting flag of joy furl out
as once it did, over my trailing hair,
over my feet, soothing the tips of my
fingers with gentleness:
I float, faint, fall
O bitter Madrigal!

My son! my son! bred from my once
quiet flesh and wholesome bone,
his dream dismantled, his new breath
trampled on,
his smile like twisted trusting leaf
by hands made of steel and ice, washed
with lyric tears,
heart and limbs that once were bright
and warm
now parceling to dust. O dream! O faith!
O love! O beauty broken!
cease pouring into my ears, bird on my shoulder,
this anguish, this blood-strewn agony;
nothing now be done to make me free,
my son forever gone from me!

O merciless Madrigal!
O bitter Madrigal!

And so he said—

I will look for you
in the spring then
said the gentle fisherman;
it is but November
and I
looking for his face
full of beauty of place.

plain men
are like that
not aware of
being thing rare
just piece of nature
in its place
this their lovable
stature.

I heard ice crack
in his talk
and the tall rock
he spoke of
became a sudden
monumental
you never see things
if you ride
how you miss the All
that's why I walk.

I am half asleep now
the moon in the wrong
slot
I will be going to sleep now
in the round thought
of his looking for me
in the spring
that will be one thing
to know the glory of one more thing to see
stave off
or best—reprove
satiety.

Three Loving Men

Adelard, Etienne
consummate men
each loving each,
each loving me, and then
showing these in a dream
of men.

We will build a house
they said—make it safe
from rain
said Adelard, Etienne.

Black went the sky
pale went the house
wind tore it out of rafter
death dancing after
house fell to ruin
for three men.

I alone am loving
two consummate men
who will not come again
because two are not now
breathing men
Adelard, Etienne.

Encompassed

Encompassed in arms
concentric—
took kin and left me happy
free
eyes burned like flames in burning
tree
tongue clogged with exquisite fury.

Hair stood on end like fury-fire
mouth blowing steam of thick desire
we will go, you will go, you will
not go, without me.

I will be thunder in your stride
I will be terror in your thickening
eyes—wide
with stricken wonder.

I will be love
you never heard of
and shoots of everlasting fear-
lessness
will break from your engendered breast
ere sun go to west
you will be utterly encompassed.

I walked along
beaten with the song.

Casual Frontier

When the sea swell takes me in
at the scattering
its saltness over my dishevelled,
shaking
bone,
and the sharpest wave tries to drown out
the last all but lost note in my throat
that is that was, for being silenced now
and compatibly still like stone,
therefore beyond brute shout—
the wind protesting impecunious will
and cannot shoulder
or heart make bolder
to bear the power of the word one
instant longer—
that word shall make itself free
of profligate mystery
and help me somehow to outcry
thanks for this immitigable parity;
my choked whisper shall have empirically then
been made clarion—
flag flung up to stave
nonsense of the grave,
or—dual faced oblivion.

Fishermen's Last Supper

For wine, they drank the ocean—
for bread, they ate their own despairs;
counsel from the moon was theirs
for the foolish contention.

Murder is not a pretty thing
yet seas do raucous everything
to make it pretty—
for the foolish or the brave,
a way seas have.

Plates

Despite his claims of objectivity, Hartley was never a representational artist, and rarely a *plein air* painter. His time out of doors was spent looking and digesting for later studio constructions. In *Nova Scotia Fish Houses,* the Leander Knickle house is in the background, but this precise view does not exist.

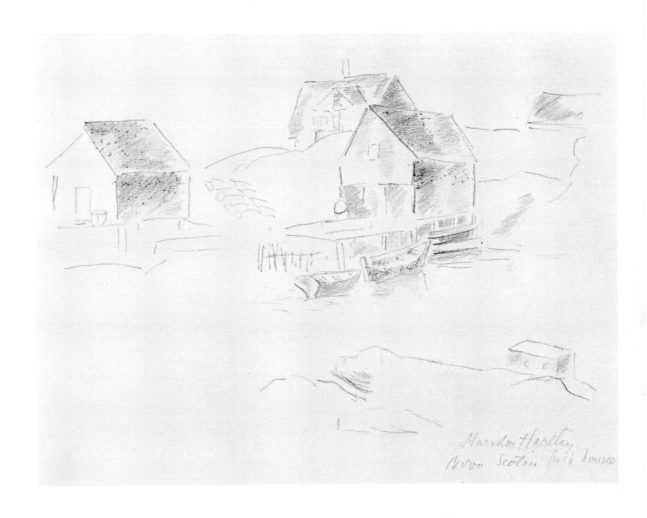

Plate 9
Nova Scotia Fish Houses, 1936.
Pencil on paper, 9 × 12″
Private Collection.

No. 32, 1936.
Pen and ink on paper, 7 × 10"
The Marsden Hartley Memorial Collection,
Bates College, Lewiston, Maine.

No. 35, 1936.
Pen and ink on paper, 7 × 10"
The Marsden Hartley Memorial Collection,
Bates College, Lewiston, Maine.

During the summer of 1936 Hartley did numerous
gestural pen and ink drawings of the landscape around
Blue Rocks. These drawings were preparatory to his
third Dogtown series which was executed in Nova
Scotia. The moraine landscape of Blue Rocks is similar to
Dogtown Common, Cape Ann, Massachusetts.

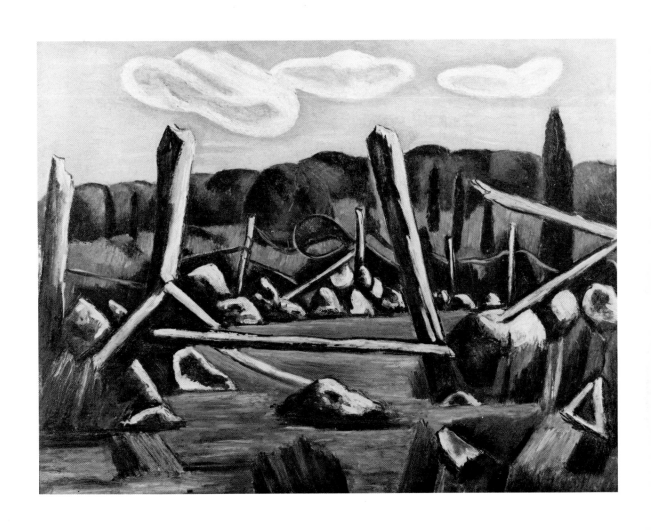

Plate 10
The Old Bars, Dogtown. 1936.
Oil on board, 18 × 24″
Whitney Museum of American Art,
New York; purchase, 1937.

No. 39, 1936.
Pen and ink on paper, 7 × 10"
The Marsden Hartley Memorial Collection,
Bates College, Lewiston, Maine.

No. 40, 1936.
Pen and ink on paper, 10 × 7"
The Marsden Hartley Memorial Collection,
Bates College, Lewiston, Maine.

The gestural drawing style Hartley used for landscape
was occasionally applied to still life. When translated to a
painting such as *Lobster Buoys and Nets,* he claimed an
emotional and formal detachment and said that if the
result had "a hint of the abstract" it was in nature itself.
The conspicuous selection of lobster buoys with the
initials "F M" and "D M", which identified the lobster
traps of Francis and Donny Mason, suggests he had
something more in mind than mere representation.

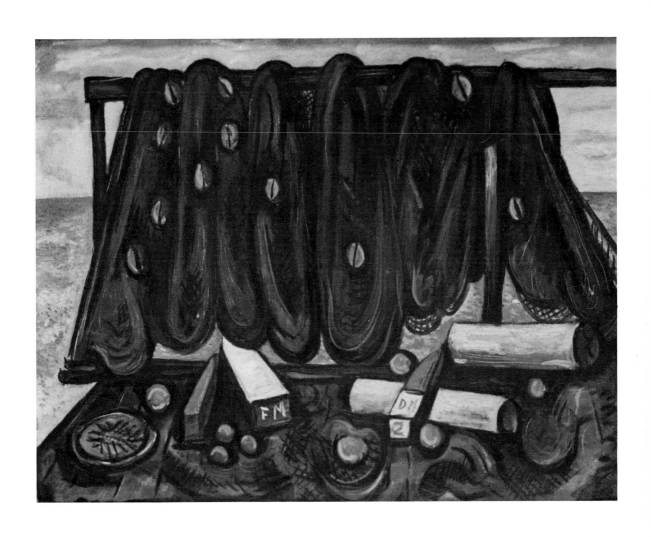

Plate 11
Lobster Buoys and Nets, 1936.
Oil on canvas, 18½ × 24″
Private Collection,
courtesy of Graham Modern Gallery, New York.

Shells and Star Fish, 1936.
Pen and ink and watercolour on paper,
15 × 15½"
Portland Museum of Art,
Portland, Maine.

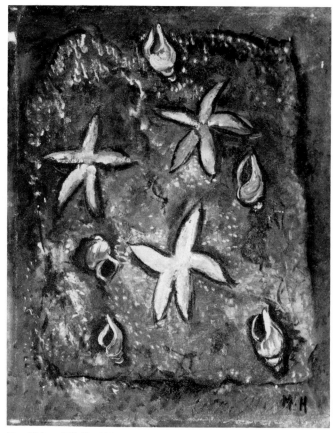

Star Fish and Shells, 1936.
Oil on canvas, 20 × 16",
Private collection, courtesy,
Rosenfeld Fine Arts, New York.

Numerous drawings of sea shells, star fish, and bits of
sea debris were executed in a pointillist style during the
summer of 1936 to intensify Hartley's powers of
observation. He denied a symbolic intent, yet he writes
of Cleophas and himself, " . . . we are two human beings
who have learned much from the university of the
imagination, he from the sea—I from the little things on
the edge of the sea . . . "

When the pointillist drawings were translated to
painting in "rich low key", Hartley still maintained that
they were objective observations. Regardless of his
claim, the rope is at least the beginnings of a sailor's knot,
similar in form to a crosier or to the rudimentary
inscription of a fish, one of the earliest symbols for
Christ. In combination with a wishbone, symbolic
neutrality is hardly possible.

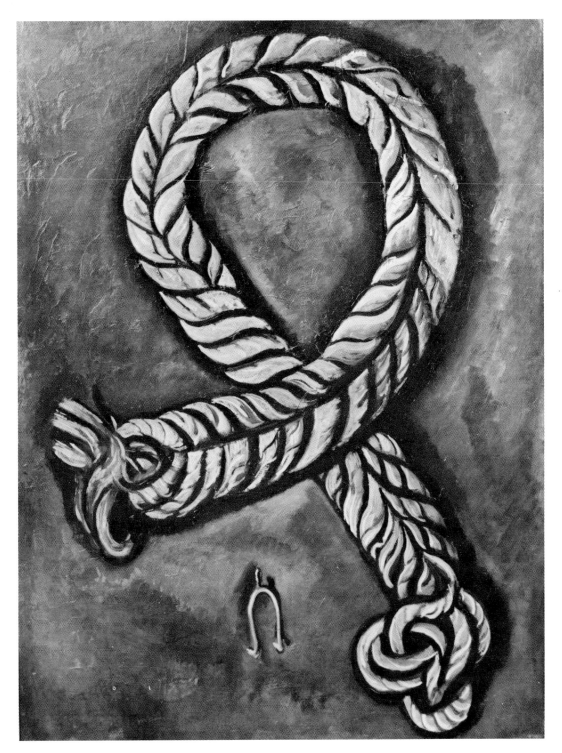

Plate 12
Rope and Wishbone, 1936.
Oil on board, 24 × 18″
Jonathan Peirce,
Bangor, Maine.

Roses for a Provincial Fisherman Lost at Sea, 1936.
verso, (detail).

Roses for a Provincial Fisherman Lost at Sea was painted in Nova Scotia after the drownings. The aureole surrounding the chalice, the heart and cruciform/stars are reminiscent of Hartley's 1912 "Intuitive Abstractions". The intense red background is the same colouration which Hartley uses in *Adelard the Drowned, Master of the Phantom* of 1938. This work was in Hartley's estate and has undergone several title changes. When it was first shown after Hartley's death at Paul Rosenberg & Co., it was labeled "Friend Against the Wind". Written in Hartley's hand on the back of the painting is "Roses for a Prov. Fisherman Lost at Sea". When it was shown at Barridoff Galleries in 1982, the title "In Memory of a Fisherman Lost at Sea (Friend Against the Wind)" appeared.

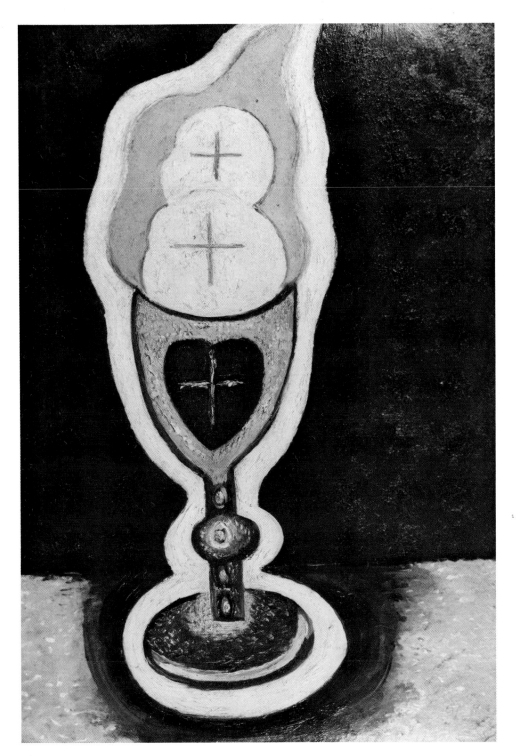

Plate 13
Roses for a Provincial Fisherman Lost at Sea,
1936.
Oil on board, 18 × 12″
Private Collection.

St. Paul's United Church,
Blue Rocks/Stonehurst.

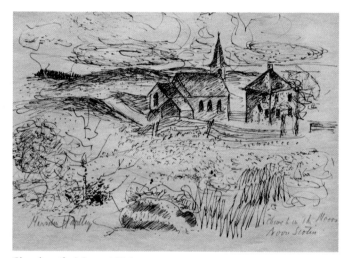

Church on the Moors, 1936.
Pen and ink on paper, 9 × 12″
Robert Leff,
Cambridge, Massachusetts.

The gestural landscape drawing with St. Paul's United
Church of Blue Rocks, done in the summer of 1936, is
transformed into the highly charged and symbolic
painting *Church on the Moors* done after the tragedy on
September 19. Since the drawing and painting are both
subjective interpretations of place, a site photograph can
only be an approximation.

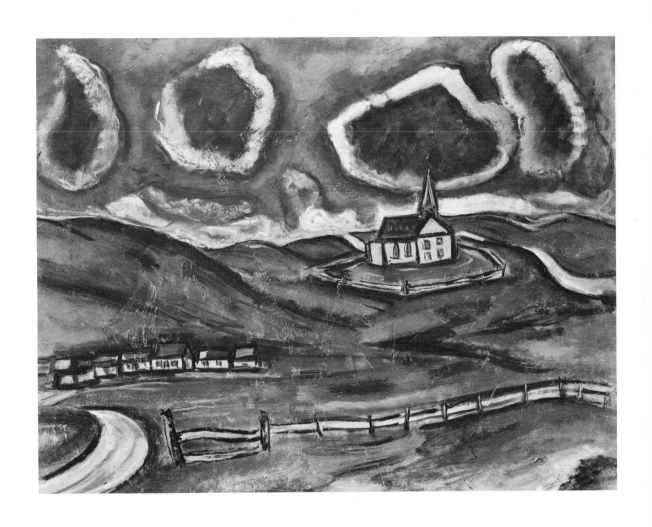

Plate 14
Church on the Moors, Nova Scotia, 1936.
Oil on board, 18 × 24"
Christopher E. Horne,
Toronto.

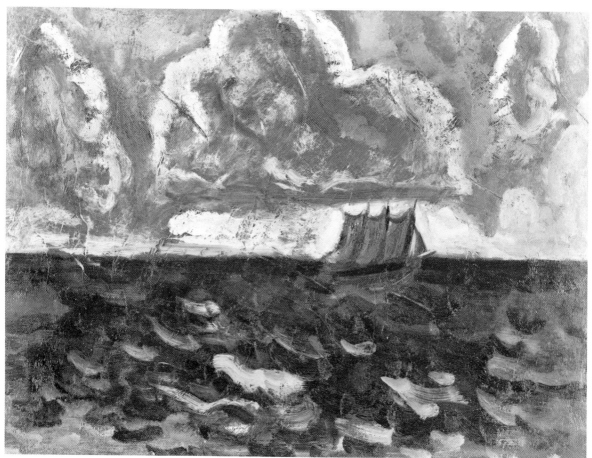

Plate 15
Off to the Banks, 1936,
Oil on board, 12 × 16"
The Phillips Collection,
Washington, D.C.

At least six oils of this size and subject were executed in
Nova Scotia after the tragedy. They have the expressive
power of *Church on the Moors* and may have been
influenced by Ryder's *Toilers of the Sea.* The symbolic
intent, however, is more than man's sufferance at the
hands of nature; it is a struggle with inevitably tragic
results.

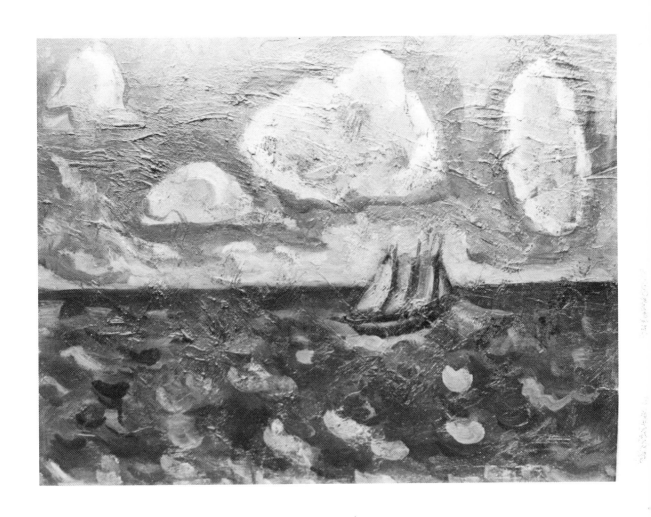

Plate 16
Stormy Sea #2, 1936.
Oil on board, 12 × 16″
William W. Farnsworth Library and Art Museum,
Rockland, Maine.

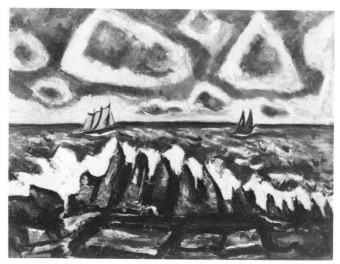

Northern Seascape, Off the Banks, 1936.
Oil on board, 18 × 24"
Milwaukee Art Center Collection;
Bequest of Max E. Friedmann

Reproduction from *Art News*, Vol. 35, May 1937,
p. 17, showing original title as *Off the Banks, Nova Scotia*.

Off to the Banks and *Stormy Sea* #2 were preparatory to
Northern Seascape, Off the Banks done in Nova Scotia in the
fall of 1936. As part of the Americanization of Hartley,
"Nova Scotia" was deleted from the title of the painting
after its first showing at Stieglitz's An American Place. A
pair of lonely ships set against a hostile sea emerged
again in a more malevolent version in 1942 with *Off to the
Banks at Night*.

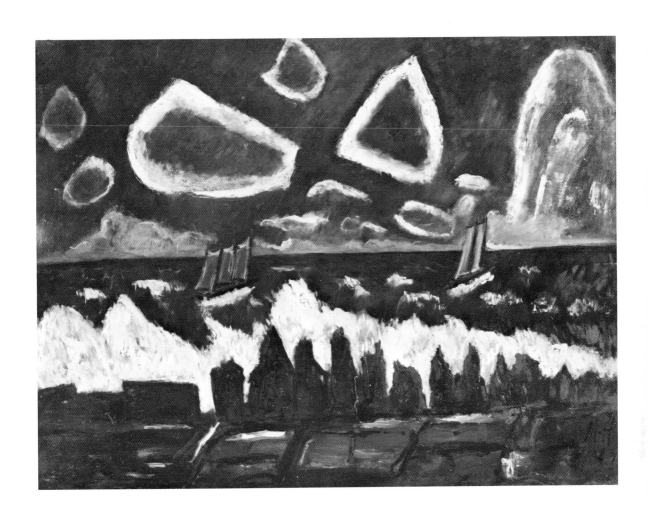

Plate 17
Off to the Banks at Night, 1942.
Oil on board, 30 × 40"
The Phillips Collection,
Washington, D.C.

Aunt Martha Churning, Nov. 1936.
Pen and ink on paper, 10 × 8"
Present whereabouts unknown.

After Hartley left Nova Scotia he produced his
remarkable memory portraits of the Masons. He wrote
to Adelaide Kuntz two years before, "How I would love
to paint a series of them all, and would, save that I would
be involved as Cézanne was with his Vollard portait
which took 80 sittings." It was the tragedy and the loss of
a family that finally directed Hartley to this effort when
he returned to Maine. *Aunt Martha Churning* is the only
known drawing of one of the family members done
while Hartley was in Nova Scotia. "Aunt" Martha is how
Martha Mason was addressed at Eastern Points, a
practice common in small rural communities. *Aunt
Martha Churning* is the model for the later painting, *Nova
Scotia Woman Churning*.

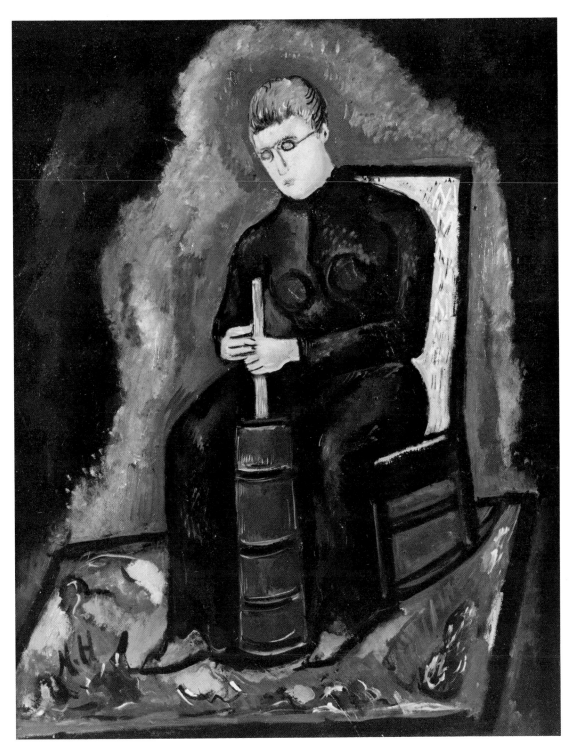

Plate 18
Nova Scotia Woman Churning, 1938-39.
Oil on board, 28 × 22"
Charles and Emma Frye Museum,
Seattle.

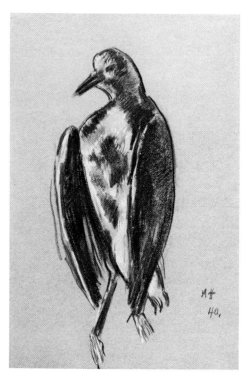

Dead Plover, 1940.
Crayon, chalk and charcoal on paper,
17$^{13}/_{16}$ × 11 $^{3}/_{4}$ "
University Art Museum,
University of Minnesota, Minneapolis;
Bequest of Hudson Walker from the Ione
and Hudson Walker Collection.

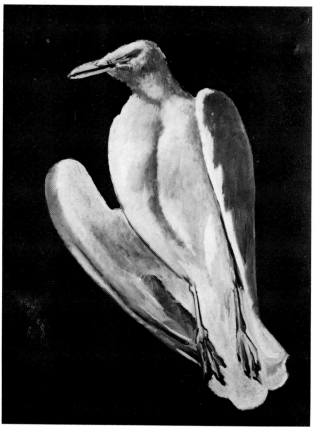

Gull, 1942-43.
Oil on board, 28 × 22"
Mr. and Mrs. Milton Lowenthal,
New York.

Labrador Ducks was painted in the Mason's empty
blacksmith shop after the drownings. Hartley said,
"They [the ducks] are a test of observation . . ." and went
on to describe to Adelaide Kuntz the precision his
favorite 17th century Dutch painters were able to
achieve. The symbolism of the work however, is
inescapable, especially after the drownings of Alty and
Donny. Hartley relates in his Journal, "Yet he couldn't
help but think of the twos that floated on the sea when
the waves had torn them from the ship & then tossed
them together . . . sailors washed ashore in each other's
arms, the last thrust of death . . ."

In the last years of his life, Hartley wrote numerous
poems and did many drawings and paintings of dead
birds. He always chose the Plover, Gull and other sea
birds — never the predator. Beyond their obvious
reference as *memento mori,* they are ". . . the very choicest
of nature's gifts . . ."

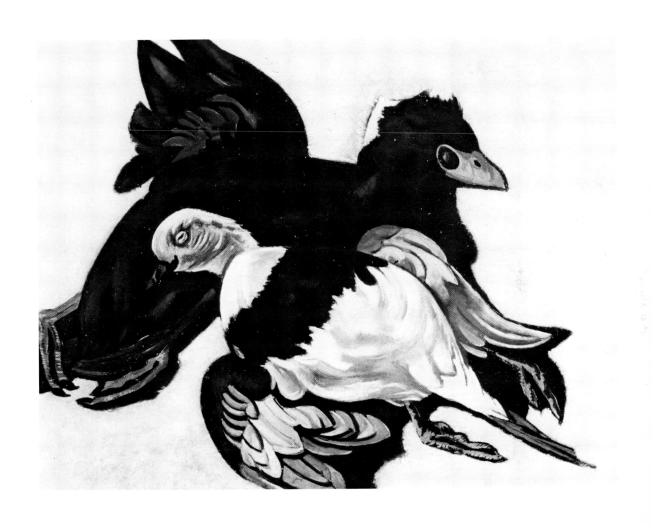

Plate 19
Labrador Ducks, 1936.
Oil on board, 18 × 24"
Private Collection,
courtesy of Graham Modern Gallery,
New York.

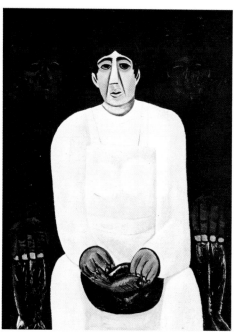

The Lost Felice, 1939. (see Plate 4).

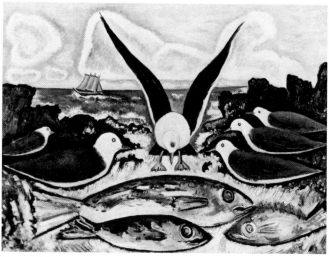

Give Us This Day, 1938-39. (see Plate 5).

After the tragedy Hartley writes, "O the look on the face of Felice." *The Lost Felice* is an allegorical portrait of Alice Mason who Hartley said was "the symbol of protection for the family." Behind her are the spectral figures of Alty and Donny holding fish, a traditional symbol for Christ. Felice has a lone fish cradled in her lap, extending the metaphor from the family to the faith.

Give Us This Day is a more generalized allegory from the same period as the Mason family portraits. It is an acceptance of the natural cycle of life, referring specifically to the drownings. Three fish, a symbol for both Christ and the three drowned boys, are the focus of the painting. The sea gulls, representing Hartley and the Mason family, are sentinel, while the large gull (Francis) says grace, " . . . & when I see Francis Mason with his majestic face say grace, 'O, God, we thank Thee, etc.' I feel so honoured to be among them." The passage of Alty, Donny and Allen is signified by the lone ship on a calm sea and clear day disappearing in the distance.

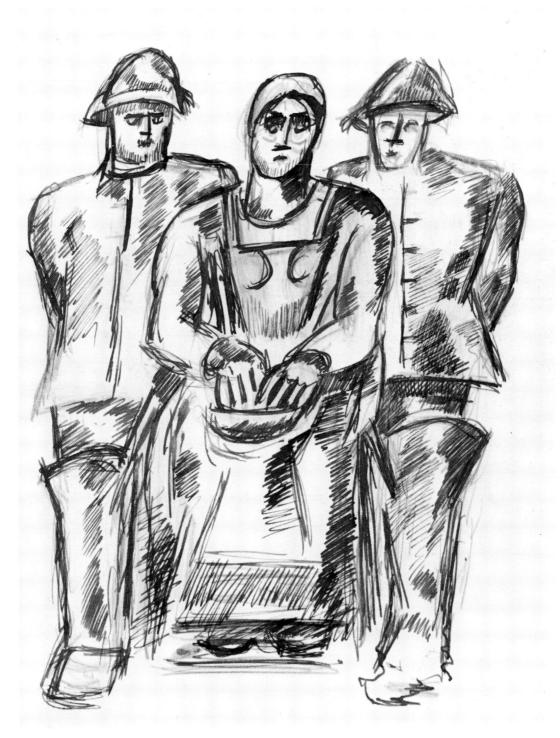

Plate 20
No. 44, [The Lost Felice], 1938.
Pen and ink on paper, 10⅜ × 8″
The Marsden Hartley Memorial Collection,
Bates College, Lewiston, Maine.

Roses is an aerial view of a wreath of roses, the symbol so
intimately associated with the Masons, floating on the
water. This painting was inspired by the annual
Fishermen's Memorial Service in Lunenburg which
Hartley attended after the drownings. The service
concludes by casting funerary wreaths upon the water
for those lost at sea.

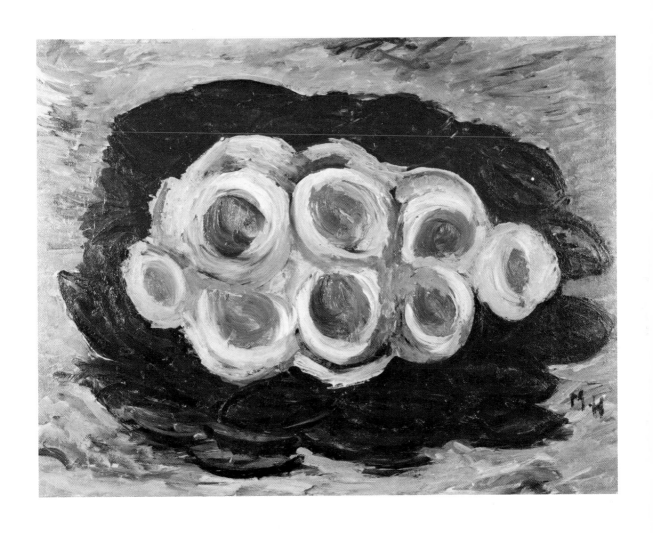

Plate 21
Roses, ca 1941.
Oil on board, 12 × 16″
Private Collection.

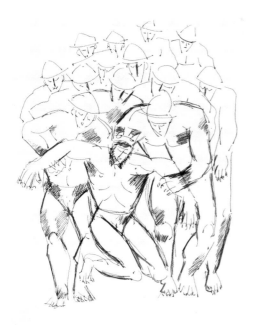

No. 81, ca 1940.
Pen and ink on paper, 10 × 8″
The Marsden Hartley Memorial Collection,
Bates College, Lewiston, Maine.

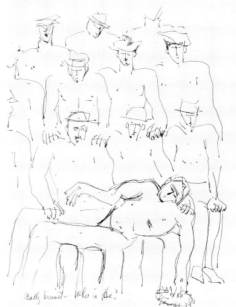

No. 82, ca 1940.
Pen and ink on paper, 10½ × 8¼″
The Marsden Hartley Memorial Collection,
Bates College, Lewiston, Maine.

By 1940 the religious content of Hartley's work had
become more apparent as in this series of pietàs. In each,
a deposed Christ is held by fishermen, but penned on
No. 82 is "Badly Bruised—Who is he?". Hartley wrote that,
" . . . the face of Alain was bruised and calm" when his
body was recovered. The meaning of sacrifice, with
Christ as the archetypal model, can now be
comprehended by Hartley who, "must have all things of
that nature humanized."

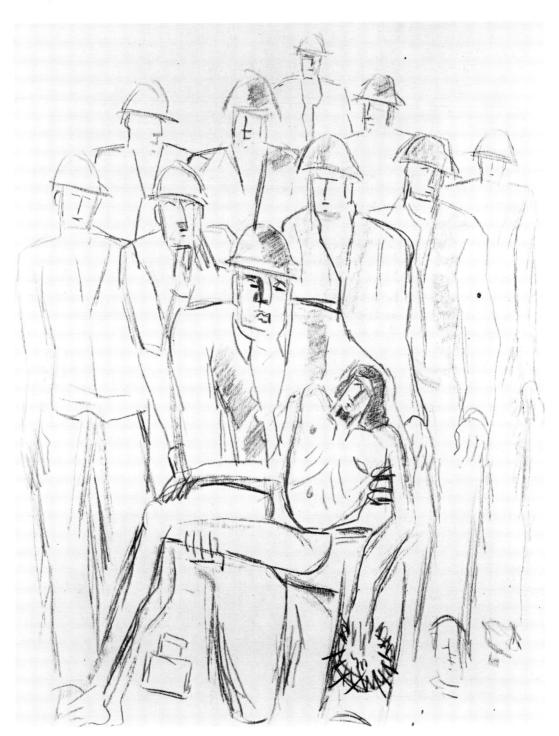

Plate 22
Christ Held by Men, 1940-41.
Lithographic crayon on board, 27 × 21½"
Private collection, courtesy of
Salander-O'Reilly Galleries, Inc.,
New York.

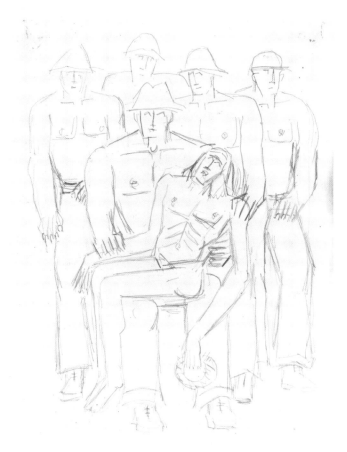

No. 80, ca 1940.
Pencil on paper, 10½ × 8″
The Marsden Hartley Memorial Collection,
Bates College, Lewiston, Maine.

Christ Held by Half-Naked Men is a title not assigned by
Hartley. The painting was in his estate and not exhibited
until after his death. This painting is a metaphor of the
unwavering faith of men like Francis Mason, who
sustain and support a vulnerable Christ, and for Hartley,
give viability to Christianity in the modern world.

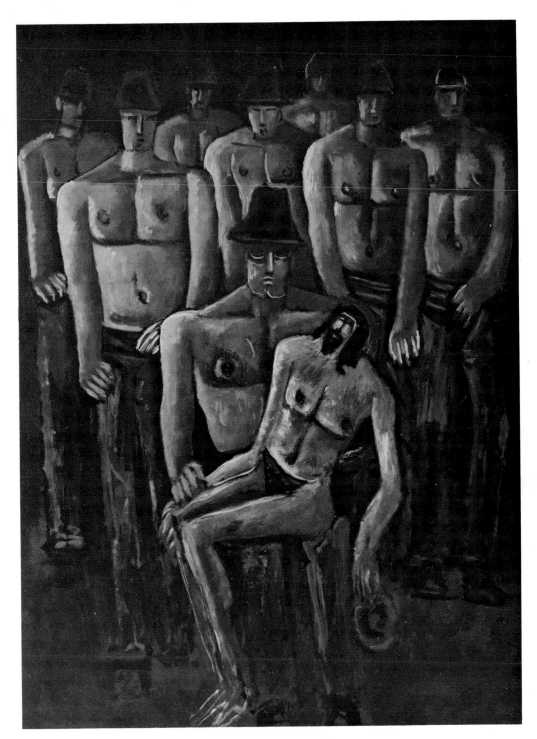

Plate 23
Christ Held by Half-Naked Men, 1940-41.
Oil on board, 40 × 30"
Hirshhorn Museum and Sculpture Garden,
Smithsonian Institution,
Washington, D. C.

Sustained Comedy—Portrait of an Object, 1939.
Oil on board, 28 × 22"
Museum of Art, Carnegie Institute,
Pittsburgh, Pennsylvania;
Gift of Mervin Jules.

This mixed and obscure symbolism has its antecedent in a rarely commented on work by Hartley—done at the same time as the memory portraits of the Masons—*Sustained Comedy, Portraits of an Object.* Hartley writes to Adelaide Kuntz after the drownings, " . . . not a day—not an hour when I do not feel nature has been so cruelly discounted, and in all truth, so cruelly deprived, for they were among the very choicest of nature's gifts, & we should not have taken from us what was so grandly given." Whatever the specifics of his private iconography, this is an angry and decidedly pessimistic picture. Hartley has even penned the word "Travesty" on the back of the painting, a word which he equates with death in his journal (p.81).

No. 97 is inscribed " 'Monstrous Betrayal' to W.H. Hudson," referring to the English writer W.H. Hudson (1841-1922) and how he felt he had been deceived by his mother about immortality. (See "On White, as an influence", an essay by Hartley in the Yale University Archive.) Much of the Christian iconography is discernible, *e.g.* the crucifixion, fishes and loaves, crown of thorns; but the form of the crucifixion, the serpent, butterflies and birds, and how the fishes and loaves weigh the flung arms of Christ, put emphasis on the word "Betrayal." These pictorial sentiments are perhaps best expressed by Hartley in *Cleophas and His Own* when he writes, " . . . How could you — how could you?".

Plate 24
No. 97, ["Montrous Betrayal" to W.H. Hudson], ca 1942.
Pen and ink on paper, 10¾ × 8"
The Marsden Hartley Memorial Collection,
Bates College, Lewiston, Maine.

The symbolism and focus of drawing *No. 97* has been modified and transformed in the painting *Adelard Ascending*. Adelard, whose "Hair stood on end like fury-fire," ascends from his island home. The tone and feeling of this work is best expressed in Hartley's poem, "Voice of the Island" from the "Postludes" section of *Cleophas and His Own.*

Plate 25
Adelard Ascending, ca 1942.
Oil on board, 28 × 22″
Present whereabouts unknown.

No. 95, ca 1943.
Pencil on paper, 10¾ × 8″
The Marsden Hartley Memorial Collection,
Bates College, Lewiston, Maine.

No. 96, ca 1943.
Pencil on paper 10½ × 8″
The Marsden Hartley Memorial Collection,
Bates College, Lewiston, Maine.

Fisherman's Family is an unfinished portrait of the Mason
family, (left to right), standing: Alty, Francis, Donny;
sitting: Martha and Alice.

166

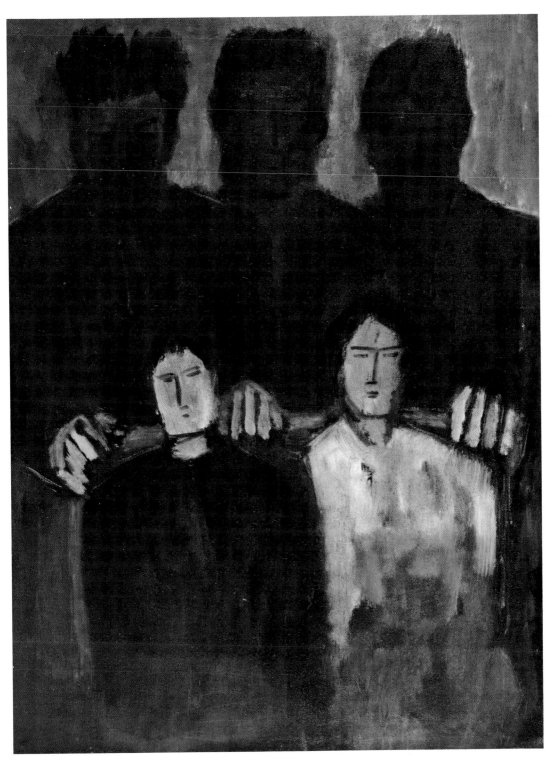

Plate 26
Fisherman's Family, 1943.
Oil on canvas, 40 × 30″
Present whereabouts unknown.

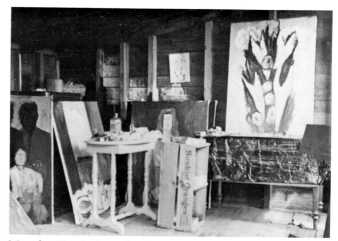

Marsden Hartley's studio, Corea, Maine, September, 1943.

No. 99, ca 1943.
Pencil on paper 10 × 7″
The Marsden Hartley Memorial Collection,
Bates College, Lewiston, Maine.

Drawing *No. 99* was tacked to the studio wall and the painting *Roses*, depicting that symbol so closely associated with the Masons, was on the easel at the time of Hartley's death. *Roses* is a transcendant bouquet, not a funerary wreath, which suggests, along with his last correspondence, that Hartley had come to terms with the past and his own imminent death.

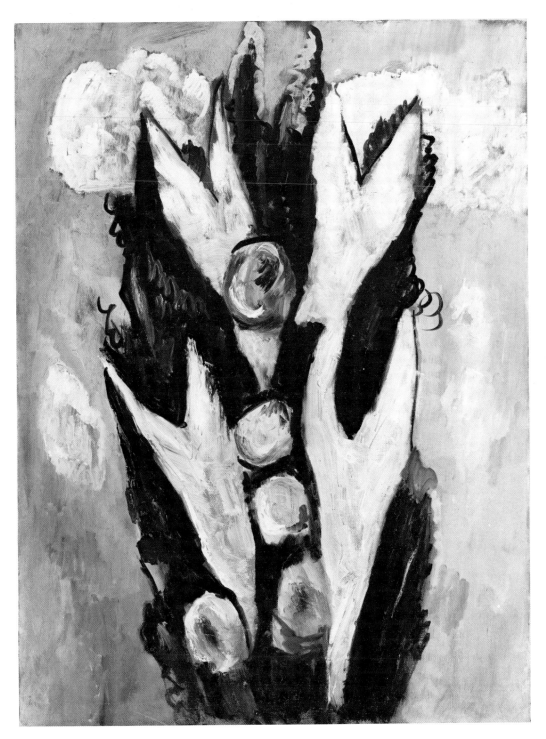

Plate 27
Roses, 1943.
Oil on canvas, 40 × 30"
Walker Art Center, Minneapolis;
Gift of Ione and Hudson D. Walker
through the T.B. Walker Foundation.

Chronology

Many details in this chronology of Marsden Hartley's life and work derive from those set forth by Barbara Haskell in *Marsden Hartley,* Whitney Museum of American Art, New York, 1980.

1877 Edmund Hartley born January 4, in Lewiston, Maine.

1885 Mother dies March 4.

1889 Father marries Martha Marsden and moves to Cleveland, leaving Edmund in Maine with a married sister.

1892 Leaves school to work in a shoe factory.

1893 Joins family in Cleveland. Takes office boy job in marble quarry.

1896 Begins weekly art classes with John Semon, a Cleveland painter.

1898 Is fired from his job at the quarry. Takes an outdoor painting class with Cullen Yates, a local Impressionist. Enters the Cleveland School of Art on scholarship.

1899 Receives a stipend for five years to pay for art study in New York City. Enters the Chase School, New York City.

1900 Returns to Lewiston, Maine. Executes botanical drawings. Transfers to the National Academy of Design, New York City, where he studies for the next four years with summers in Maine.

1904 Stipend runs out. Takes a job with Proctor's Theatre Company, New York for the next two years. Meets Horace Traubel, Walt Whitman's biographer; regular meetings and an extensive correspondence continue until 1915.

1906 Adopts his step-mother's maiden name, Marsden. Calls himself Edmund Marsden Hartley.

1907 Produces Impressionist landscape paintings. Goes to Green Acre, a mystical-intellectual retreat in Eliot, Maine. First exhibition is held at the home of Mrs. Ole Bull in Eliot, Maine.

1908 Drops his first name. Calls himself Marsden Hartley. Exhibits a painting at Rowlands Gallery, Boston. Returns to North Lovell, Maine. Does Neo-Impressionist painting and drawings.

1909 Visits Boston and shows paintings to Maurice and Charles Prendergast who write letters of introduction to William Glackens. Takes paintings to New York City where Glackens arranges to show them in his studio to The Eight. Meets Alfred Stieglitz through Seumas O'Sheel. First one-man show at 291, its first one-man show by an American artist. N.E. Montross, a dealer, introduces Hartley to the work of Albert Pinkham Ryder. Receives a $4 per week stipend from Montross for the next two years. Paints landscapes influenced by Ryder on his return to Maine.

1910 Becomes a regular member of the Stieglitz circle.

1911 Experiments with abstract compositional techniques derived from Picasso. Hospitalized for five weeks with scarlet fever. Sees works by Cézanne. Does Cézannesque still lifes.

1912 Second one-man show at 291. Makes first trip abroad; arrives in Paris in April. Paintings and drawings selected by Arthur B. Davies and Walt Kuhn for the Armory show. Introduced to Der Blaue Reiter and to Kandinsky's *Über das Geistige in der Kunst* ("On the Spiritual in Art"). Travels to London for a show. Becomes a regular visitor to the Gertrude Stein salon. Meets Arnold Rönnebeck and his cousin, Lieutenant Karl von Freyburg.

1913 Meets Franz Marc. Goes to Munich with Marc and Rönnebeck to meet Kandinsky and Gabriele Münter. Included in the "International Exhibition of Modern Art" (The Armory Show). Intuitive Abstractions increasingly influenced by Kandinsky. Gertrude Stein selects four paintings to be hung in her apartment. Begins Ante-War paintings in Berlin. Included in the first German Autumn Salon with the Blaue Reiter group. Sails for New York City for an exhibition at 291. Meets and becomes a close friend of Mabel Dodge and John Reed.

1914 Third one-man show at 291. Returns to Berlin. Symbolic martial paintings begin after war is declared on August 3. Father dies on August 4. Karl von Freyburg is killed in battle on October 7. Begins a series of German Officer Portraits.

1915 Step-mother, Martha Marsden Hartley dies in May. Major one-man exhibition held at Münchener Graphik-Verlag, Berlin. Returns to New York City. Attends Walter Arensberg's salon.

1916 Nine works by Hartley included in "The Forum Exhibition of Modern American Painters" at the Anderson Galleries. One-man show of German martial paintings at 291 badly received. Goes to Provincetown, Massachusetts as the summer guest of John Reed. In the fall shares a house in Provincetown with Charles Demuth. Goes to Bermuda that winter with Demuth. Develops a close friendship with Louise Bryant.

1917 Leaves Bermuda for New York City. Has his appendix removed. Goes to Ogunquit, Maine art colony with Carl Sprinchorn, Robert Laurent, and Maurice Sterne. Exhibits in the "First Annual Exhibition of the Society of Independent Artists".

1918 Arrives in Taos, New Mexico and stays with Mabel Dodge. Does a series of paintings based on santos figures.

1919 Visits Carl Sprinchorn in La Canada, California where he meets Robert McAlmon and Arthur Wesley Dow. Returns to New Mexico and does pastel landscapes. Returns to New York City.

1920 Appointed first Secretary of the Société Anonyme, Inc., founded by Marcel Duchamp, Katherine Dreier and Man Ray. Summers in Gloucester, Massachusetts; Elie Nadelman and Stuart Davis are there.

1921 Gives lecture entitled "What is Dada?" at the Société Anonyme. With Henry McBride, Katherine Dreier and Mina Loy, gives a reading of works by Gertrude Stein at the Société Anonyme for "The First Birthday Party—An Evening with Gertrude Stein." Auction of 117 works at the Anderson Galleries to raise money for his return to Europe. Renews his friendship with Louise Bryant, John Reed's former wife and now married to William Bullitt, the future American Ambassador to France. Bullitt proposes a syndicate to provide Hartley with living expenses in exchange for paintings. On his way to Berlin, Hartley visits John Storrs in Orleans. *Adventure in the Arts,* a book of Hartley's essays is published.

1922 Makes his first lithographs in Berlin.

1923 Begins New Mexico Recollections series. Does pastel nudes, the first figurative work since his drawings of 1908. *Twenty-Five Poems,* his first book of poetry, is published by Robert McAlmon's Contact Publishing Company, Paris. Travels to Italy and spends Christmas with Maurice Sterne.

1924 Sails for New York to arrange details with Bullitt for the syndicate which finances him for the next four years. Returns to Paris via London. Continues New Mexico Recollections and begins Paysages series of Ryderesque recollections of Maine.

1925 Moves to Vence, France.

1926 Moves to Aix-en-Provence and works in a Cézannesque manner.

1927 Travels to Paris, Berlin and Hamburg. Returns to Aix-en-Provence and begins his Mont Sainte-Victoire paintings.

1928 Returns to New York City. Visits his show at The Arts Club of Chicago; continues on to Denver to visit Arnold Rönnebeck who became director of the Denver Museum. In the summer visits the Bullitts in New Hampshire; goes to Georgetown, Maine to be with Paul and Rebecca Strand and Gaston and Mme. Lachaise. Returns to Paris and begins his first painting in over a year.

1929 Mont Sainte-Victoire landscapes are shown by Stieglitz at the Intimate Gallery and are badly received. Goes back to Aix-en-Provence and later travels to Paris, Hamburg, Berlin and Dresden.

1930 Returns to New York City and then New Hampshire. After New Hampshire landscapes, does not paint for eight months.

1931 Ill with bronchitis. Receives a Guggenheim grant to paint for a year but it stipulates that he must leave the United States; he plans to go to Mexico. Summers in Gloucester, Massachusetts and begins the first of three Dogtown series, a moraine area near Gloucester. Spends Christmas in Cleveland with his sister and nephew.

1932 Goes to Mexico City and later Cuernavaca where his friend Hart Crane was living in a community that included Paul Strand and Mark Tobey. Does a series of paintings with esoteric Christian mystical symbols. Paints *Eight Bells' Folly* after learning of Hart Crane's suicide.

1933 Leaves Mexico for Germany. Stays in Hamburg and then moves to Garmisch-Partenkirchen and begins a series of paintings and lithographs of the Bavarian Alps.

1934 Returns to New York City. Employed by the Federal Government on the Public Works of Art Project in the easel division. Goes to Gloucester and does his second Dogtown series. Returns to New York City.

1935 Destroys over 100 paintings in order to accommodate his stored works in a single vault. Travels to Bermuda for reasons of health. Paints tropical fish fantasies. Is encouraged by his long-time friend, Frank Davison, to join him in Nova Scotia. Arrives at Lunenburg, N.S., moves on to Blue Rocks and eventually meets the Francis Mason family with whom he boards on nearby East Point Island. Returns to New York City.

1936 Employed by the Works Progress Administration. His show at Stieglitz's An American Place of "Bermuda Fantasies" and Bavarian Alps paintings is badly received. Returns to the Mason family in Nova Scotia. Paints sea debris still lifes and begins his third Dogtown series because of the similarity in landscape of the Blue Rocks area. On September 19 the two Mason sons and their cousin drown in a boating accident. Paints brooding Ryderesque landscapes and seascapes and related symbolic paintings. Writes *Cleophas and His Own*. Returns to New York City.

1937 Health is bad during the winter. Finishes his Nova Scotia paintings. Opens his last show with Stieglitz at An American Place. Show is not well received; Stieglitz is critical. Returns to Maine.

1938 First exhibition at the Hudson D. Walker Gallery, New York City. Moves to Vinalhaven, an island off the Maine Coast. Begins a series of portraits of the Mason family from memory, the first figurative paintings in his career.

1939 Returns to New York City and continues working on the portraits of the Masons. Returns to Maine in the summer and stays with John Evans, the son of Mabel Dodge. Financial situation is desperate; describes himself as a "first class hater now." Waldo Peirce assists in getting him a job teaching painting at the Bangor Society of Art which he detests. Waldo Peirce introduces him to Corea, Maine. Takes an eight-day trip to Mt. Katahdin, north of Bangor. Applies for a Guggenheim and is rejected. Begins a series of Mt. Katahdin paintings which he works on for the next three years.

1940 Returns to New York City and his last show at the Hudson D. Walker Gallery; the gallery closes later that year. Moves to Corea, Maine and boards with Forest and Katie Young. Corea reminds him of Blue Rocks and Eastern Points. He types the *Cleophas* manuscript, and *Androscoggin*, a book of his poetry, is published by Falmouth Publishing House in Portland, Maine. Begins new figurative works based on sunbathers and lobstermen and also a series of religious subjects.

1941 Returns to New York City. Hudson Walker purchases twenty-three paintings for $5,000.00. Returns to Corea. *Sea Burial,* a second book of poetry, is published by Falmouth Publishing House in Portland. Suffers from high blood pressure and an enlarged heart. Paints sea window still lifes and continues to work on figure paintings and Mt. Katahdin series. Travels to Cincinnati for a joint exhibition with Stuart Davis at the Art Museum. Goes to Cleveland for Christmas.

1942 Lectures in Cincinnati: "Is Art Necessary-What is its Social Significance?" Returns to Corea. Paul Rosenburg & Co. becomes his dealer. Begins a new series of sea window still lifes and another Mt. Katahdin series. Paints dead sea birds. Receives painting purchase prize of $2,000.00 in the exhibition "Artists for Victory" at the Metropolitan Museum of Art, New York.

1943 Returns to New York City and paints in George Platt Lyne's photographic studio. Returns to Corea; is in very bad health. Writes a "Document of Identification" designating his niece Norma Berger, his nephew Clifton Newell and Hudson Walker be notified in the event of his death. Dies of heart failure in hospital at Ellsworth, Maine, on September 2.

Marsden Hartley,
Corea, Maine, ca 1943.

Selected Bibliography

Burlingame, Robert. *Marsden Hartley: A Study of His Life and Creative Achievement.* Providence: Brown University, 1954.

Eldredge, Charles. *Marsden Hartley, Lithographs and Related Works.* Lawrence: University of Kansas Museum of Art, 1972.

Guilbaut, Serge. *How New York Stole the Idea of Modern Art: Abstract Expressionism, Freedom, and the Cold War.* Chicago: The University of Chicago Press, 1984.

Greenberg, Clement. "Art," *The Nation,* 159 (Dec. 30, 1944), pp. 810-11.

Hartley, Marsden. *Adventures in the Arts.* New York: Boni and Liveright, 1921.

Hartley, Marsden. *Twenty-Five Poems.* Paris: Contact Publishing Co., 1923.

Hartley, Marsden. *Androscoggin.* Portland, Maine: Falmouth Publishing House, 1940.

Hartley, Marsden. *Sea Burial.* Portland, Maine: Falmouth Publishing House, 1941.

Hartley, Marsden. *Selected Poems,* ed. Henry W. Wells. New York: The Viking Press, 1945.

Hartley, Marsden. *Cleophas and His Own, A North Atlantic Tragedy,* ed. Gerald Ferguson. Halifax: A Press, 1982.

Haskell, Barbara. *Marsden Hartley.* New York: Whitney Museum of American Art, 1980.

Homer, William I., ed., *Heart's Gate: Letters Between Marsden Hartley & Horace Traubel, 1906-1915.* Highlands, North Carolina: The Jargon Society, 1982.

Homer, William I., ed. *Avant-Garde Painting and Sculpture in America, 1910-1925.* Wilmington: Delaware Art Museum, 1975.

King, Lyndel. *Marsden Hartley, 1908-1942,* The Ione and Hudson D. Walker Collection. Minneapolis: University Art Museum, University of Minnesota, 1984.

Levin, Gail. *Marsden Hartley: A Catalogue Raisonné.* New York: Salander-O'Reilly Galleries, Inc., forthcoming 1989.

Ludington, Townsend. *Marsden Hartley: A Biography.* Boston: Little, Brown & Co., forthcoming 1988.

Lynch, Michael. "A Gay World After All; Marsden Hartley (1877-1943)," *Our Image: The Body Politic Review Supplement,* no. 6 (December-January 1976-77), pp. 1-3.

McCausland, Elizabeth. *Marsden Hartley.* Minneapolis: University of Minnesota Press, 1952.

McCausland, Elizabeth and Cowdrey, M.B. "Marsden Hartley," *Journal of the Archives of American Art,* January 1968, pp.9-12 (Interview with Hudson Walker).

Mitchell, William J. *Ninety-Nine Drawings by Marsden Hartley.* Lewiston, Maine: Bates College, 1970.

Museum of Modern Art, New York. *Feininger/Hartley* (joint catalogue for contemporaneous retrospectives) October 24-January 14, 1945.

Nasgaard, Roald. *The Mystic North: Symbolist Landscape Painting in Northern Europe and North America 1890-1940.* Toronto, Canada: University of Toronto Press, 1984.

Paulson, Ronald. "Marsden Hartley: The Search for the Father(land)". *Bennington Review,* Number eight, September 1980, pp. 63-68.

Schwartz, Sanford. *The Art Presence.* New York: Horizon Press, 1982.

Scott, Gail R. ed., *On Art* by Marsden Hartley. New York: Horizon Press, 1982.

Scott, Gail R. ed., *The Collected Poems of Marsden Hartley: 1904-1943.* Santa Rosa, California: Black Sparrow Press, 1986.

Scott, Gail R. *Marsden Hartley.* New York: Abbeville Press, forthcoming 1988.

Walker, Hudson D. "Marsden Hartley." *Kenyon Review,* Vol. IX, No. 2 (Spring, 1947), pp. 248-259.

Acknowledgements

This book is the result of an exhibition which I curated for Mary Sparling, Director of the Art Gallery, Mount Saint Vincent University, and would not have been possible without her efforts over the past three years. I would like to thank Roald Nasgaard, Chief Curator of the Art Gallery of Ontario, for his consultation and essential cooperation; and Garry Neill Kennedy, President of the Nova Scotia College of Art and Design, for making available the facilities of the College and The Press to produce this book. The Collection of American Literature, the Beinecke Rare Book and Manuscript Library, Yale University kindly granted permission to publish *Cleophas and His Own*, correspondence, journal entries, and poetry from their Marsden Hartley Archive.

Gail R. Scott played an invaluable role in this project, freely sharing her considerable knowledge of Hartley and providing her transcriptions of his letters and journal. For that, and her essay, "Cleophas and His Own, The Making of a Narrative", my sincere appreciation. I also want to thank Ronald Paulson who so eloquently gives voice and perspective to Hartley's later work in his contributing essay, "Marsden Hartley's Search for the Father(land)."

I am grateful for the professionalism and generosity of: David LeBlanc for his design and production supervision; Lawrence Weiner for his jacket design; John Doull for his careful attention in proofreading the manuscript; Marlene Abbott for preparing the manuscript in the Computer Centre of the Nova Scotia College of Art and Design; Florence Carrigan and Marlene Abbott for their many hours of typing and related assistance; and Mary Ferguson for her valuable suggestions.

To the lenders I extend a special thanks for making the exhibition possible and to the many individuals and institutions who provided photographs, documentary material, and other assistance, most notably: Mrs. Hudson D. Walker; Berta Walker of Graham Modern

Gallery; Lyndel King of the University Art Museum, University of Minnesota; Barbara Haskell of the Whitney Museum of American Art; Kathryn Hargrove of Bates College and Gertrude Dennis of Weyhe Gallery. Support from colleagues and friends who were helpful in various ways include: Babcock Galleries, Barridoff Galleries, Benjamin Buchloh, Chris Huntington, Gail Levin, Murray Lively, Townsend Ludington, Thomas McFarland, Grete Meilman Fine Art, Jonathan Peirce, Alison Rossiter, Salander-O'Reilly Galleries, Jonathan Weinberg, David Whidden and Dennis Young.

I am indebted for the time, material and insight provided by Richard and Edwin Mason who grew up at Eastern Points, East Point Island. Richard Mason's recollection of Hartley, and his stories about Alty Mason who worked for him at Power's Motors in Lunenburg, were especially helpful. I am also grateful to Walter Flower of Eastern Points for his kind cooperation.

G.F.

Photographic Credits

Photographs not acknowledged in the following list have been supplied by the owners or custodians of the works, as cited in the captions.

Marsden Hartley, ca 1941. Photograph by Louise Young.

The text of this book was set in Andover.
Typesetting by:
McCurdy Printing & Typesetting Limited
Halifax, Nova Scotia